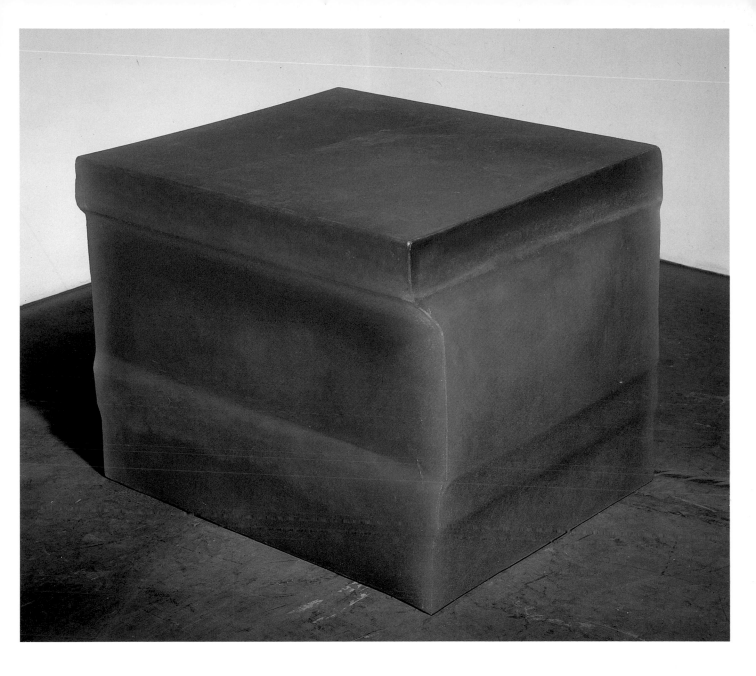

MODERN ARTISTS

First published 2004 by order of the Tate Trustees
by Tate Publishing, a division of Tate Enterprises Ltd,
Millbank, London SW1P 4RG
www.tate.org.uk
© Tate 2004

British Library Cataloguing in Publication Data
A catalogue record for this book is available from the
British Library
ISBN 1 85437 519 9 (pbk)
Distributed in the United States and Canada by
Harry N. Abrams, Inc., New York
Library of Congress Cataloging in Publication Data
Library of Congress Control Number: 2003112065
Designed by UNA (London) Designers
Printed in Singapore

Front cover (detail) and previous page:
UNTITLED (RUBBER PLINTH) 1996 (fig.44)
Overleaf: UNTITLED (BOOK CORRIDORS) 1998 (detail, fig.64)
Measurements of artworks, where known, are given in
centimetres, height followed by width and depth. Inches are
given in parentheses.

Author's acknowledgements

My thanks go to Rachel Whiteread for her time, patience
and support over the years. Lewis Biggs, Mary Richards,
Hazel Willis, James Elliott, Cristina Colomar, Mark Francis,
Helen Beeckmans, Emma Woodiwiss, Valerian Freyburg,
Melissa Larner and Tyrone Lou made this book a reality, and
I thank them for making it happen. Finally my love and
thanks to Paul Ayres for his continued encouragement and
understanding.

Artist's acknowledgements

In memory of my parents, Pat and Tom Whiteread.
My thanks to Charlotte Mullins for writing this book, to
Lewis Biggs, Mary Richards and all at Tate Publishing.
To Hazel Willis, to Lawrence Luhring, Roland Augustine and
Claudia Altman-Siegel at Luhring Augustine Gallery, to
Mark Francis and Cristina Colomar at Gagosian Gallery, for
their continued professional support. To James Elliott, to my
studio assistants for their continued technical support.
Finally, my love and thanks to Marcus and Connor for being
there.

RACHEL WHITEREAD

RW

Charlotte Mullins

Tate Publishing

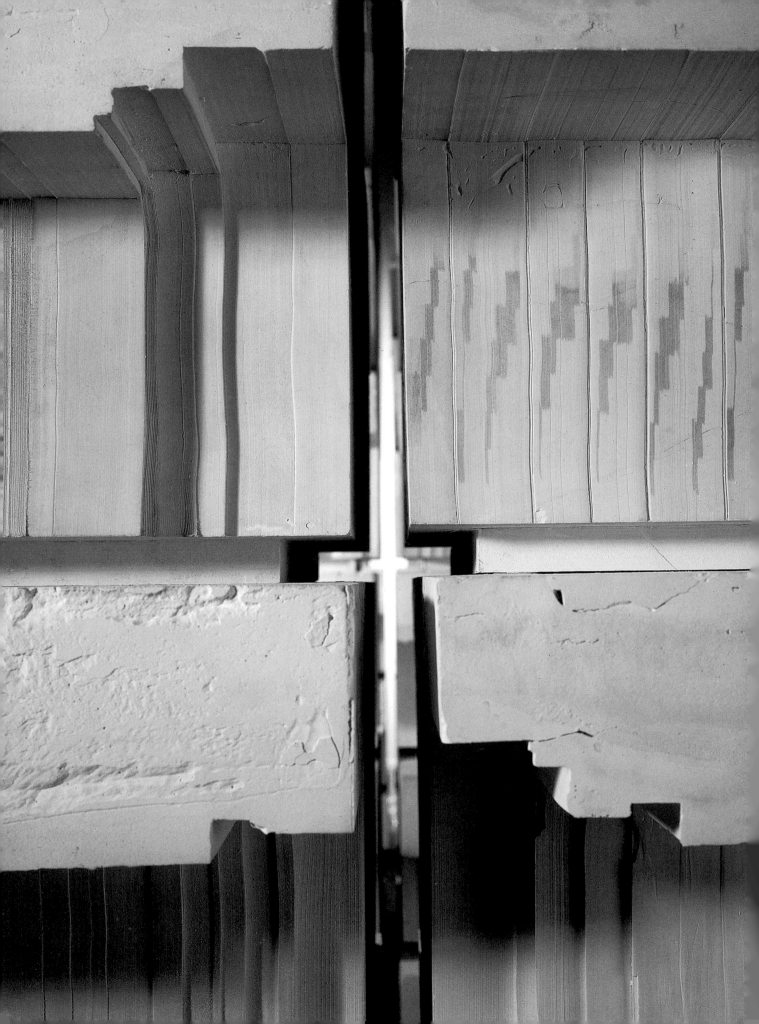

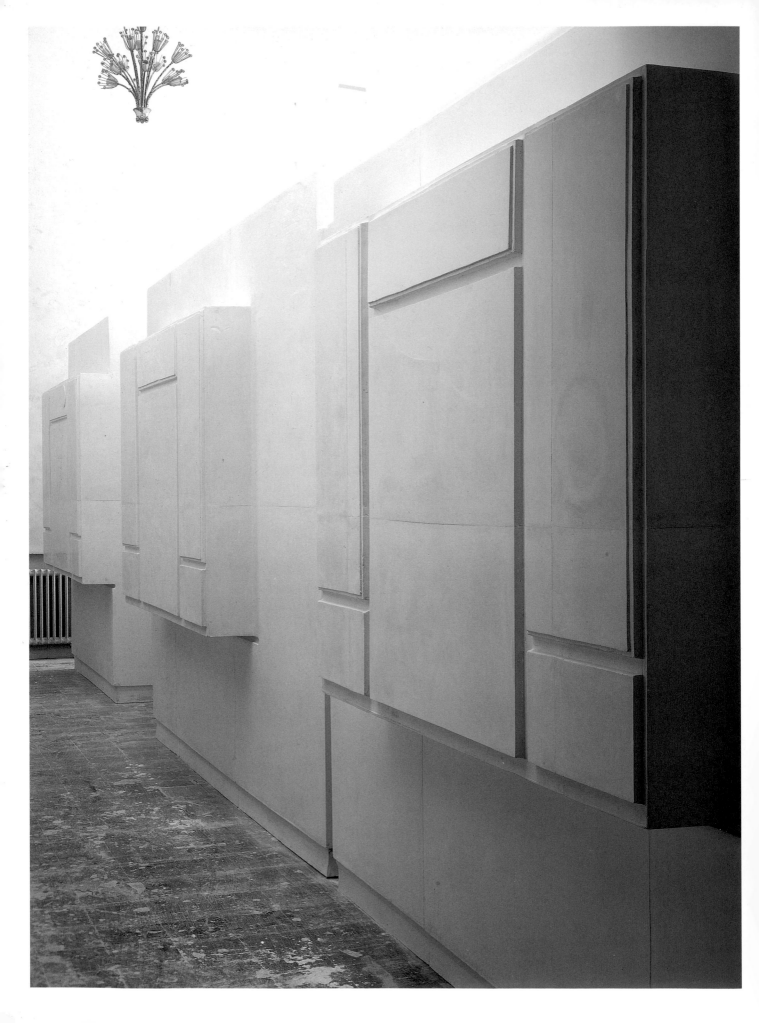

UNTITLED (ROOMS) 2001 [1]
Mixed media
282 × 726 × 1343 (111 ⅛ × 286 × 529 ⅛)
Tate. Purchased with funds provided
by Noam and Geraldine Gottesman
and Tate International Council 2003

UNTITLED (CLEAR TORSO) 1993 [2]
Polyurethane resin
10 × 18 × 25.5 (3 ⅞ × 7 ⅛ × 10)
Private Collection

BEGINNINGS

Rachel Whiteread's sculptures subtly yet deter-minedly disturb the status quo. From her earliest casts of wardrobes and hot-water bottles to her recent series of towering staircases, her body of work consti-tutes an ever-expanding lexicon of overlooked spaces. She inverts everyday objects, turning them into ghostly negatives of themselves, uncanny replicas that seem familiar yet strange.

Whiteread's early plaster sculptures – created from workaday post-war bedroom furniture, the child-hood territory of her generation – turned private spaces into public ones. The secret surfaces of a dress-ing table and bed, for example, were brought into the light for scrutiny. Whiteread excavated memories like an archaeologist, continuing to hunt for traces of past human life as she went on to cast a room, then a whole house. When she began creating ahistoric objects such as plywood living units and stand-alone floors to further her investigation into form and materials, her work became increasingly abstract. The fragments of paint, the soot in the grate, the dents and chips in tabletops – all captured in the surfaces of her early plaster works – disappeared when she cast in resin and rubber, revealing the three-dimensional solidity of the spaces underneath and behind objects.

Her interest in objects may have shifted from the personal and specific (items of a remembered bed-room) to the universal (faceless rooms, anonymous staircases), but each cast reveals clues that point to shared histories. Throughout her career, Whiteread's works have remained inherently suggestive of the human body and its cycles. This is true even of her recent public projects. *Water Tower* 1998 (p.80), is a cast of a New York storage tank, the 'bladder' of the house, while *Monument* 2001 (p.94) is a replica of an empty plinth in Trafalgar Square that was originally intended as a podium to commemorate dead subjects.

Whiteread was born in April 1963, in a Victorian house in Ilford, East London. Her mother Pat was an artist, a socialist and a great supporter of the feminist cause – in 1980 she helped organise the first feminist art exhibition in London, *Women's Images of Men*, at the Institute of Contemporary Art. Thomas, her father, was a geography teacher who later worked as a Polytechnic administrator, and was a lifelong supporter of the Labour Party. Rachel and her elder twin sisters Lynne and Karen grew up imbued with their beliefs. When Whiteread was four, her family moved to Essex, but they returned to the city three years later, and Whiteread spent the rest of her childhood in Muswell Hill, North London. At Creighton Comprehensive, she entered the sixth form studying arts and science A-levels, in part chosen to distinguish herself from her artist mother. But at the last minute she switched to art, and suddenly couldn't get enough of it.

After completing a foundation course at Middlesex, Whiteread moved to Brighton to study painting at the Polytechnic. For the first two years, her subject matter was the landscape that her father had brought to life for her as a child, by pointing out natural phenomena and the specific ways in which certain stones weath-ered. But her interest was not in painting traditional oils; her works rarely even stayed within the confines of the canvas or paper, but extended out onto the wall and floor, becoming three-dimensional drawings that occupied real space, the space normally reserved for sculpture.

A workshop given by the sculptor Richard Wilson during Whiteread's time at Brighton increased her interest in three-dimensional form. It wasn't a com-plex workshop – her real training in sculpture came later, at the Slade – but through the simple process of pressing a spoon into sand, and then pouring lead into

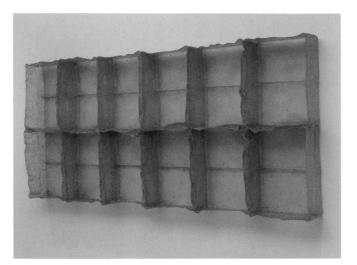

Eva Hesse
SANS II 1968 [3]
Fibreglass and polyester resin
Each unit 96.5 x 91.5 x 15.6 (38 x 86 x 6 ⅛)
San Francisco Museum of Modern Art, Purchased
through a gift of Phyllis Wattis

the curved impression that remained, she cast her first negative space. While the mould had been made from a functional piece of cutlery, the resulting cast in solid lead was an abstract domed form, a cast of the space normally occupied by the spoon *and* the space inside it. The properties of the spoon had disappeared, and it had been transformed into something altogether different. This fascination with both physical and mental transformation was to form the core of much of her subsequent work.

While at Brighton, Whiteread collected flotsam from the beach, picking up squashed cans, old drain-pipes and even a discarded mantelpiece. She took simple wax casts from them, still seeing them as drawings in space but in fact making her first forays into sculpture. By the end of her degree at Brighton, Whiteread was spending more time in the sculpture department than in the painting school. Her tutors suggested that she should switch from the painting to the sculpture course, but she refused – just because her work wasn't two-dimensional, she reasoned, it didn't mean that it wasn't painting. She graduated with First Class Honours.

Given that Whiteread has made her name as a sculptor, it's hard to understand why she was so adamant to remain on the painting course, but when she left Brighton, she still wasn't convinced that her future lay in sculpture. She applied to two London colleges to study for an MA in Fine Art, and was offered both a place on the painting course at Chelsea, and one at the Slade to study sculpture.

She eventually chose the Slade and sculpture, and spent the next two years continuing her exploration of old, abandoned objects. With no beach to comb, she bought things from junk and charity shops – old carpets, clothes, stools – or turned to items that she had used herself as a child – a checked blanket, an

occasional table. Whiteread rendered these objects useless through various devices: one leg was cut off a stool, its underside stuffed with an eiderdown; a wardrobe was tipped on its side and propped on a cushion on a bentwood chair, its door hanging open like a trap.

As a student, Whiteread was fascinated by the work of Eva Hesse. She admired the fragility of pieces that spanned corners, spilled over the floor and were suspended from the ceiling, drawing shapes across the room (fig.3). She felt a connection with Hesse (who died in 1970 aged thirty-four) through her use of delicate materials to make robust works that commented on vulnerability as they sliced through galleries, probing negative space. While Whiteread later became interested in the formal properties of the work of male Minimalists such as Carl Andre and Donald Judd, something of the feminine sensibility of Hesse's post-Minimalist work – which could be both formal and emotional simultaneously – has constantly informed her practice.

Whiteread was also interested in the work of the generation of British artists immediately prior to her own, the 'New British Sculptors'. They included Tony Cragg, whose murals were composed of bits of coloured plastic picked up from the street, and Bill Woodrow, who used old washing machines and ironing boards to create new forms such as Indian headdresses and electric guitars. She went on regular visits to London's galleries, and admired Antony Gormley's casts of his body, and the abstract sculpture of Alison Wilding, which was also suggestive of human presence.

During this time, Whiteread started casting from her own body in wax. Used for thousands of years to take death masks and make human simulacra, wax has a capacity to hold light within itself and is an uncanny

UNTITLED 1987 [4]
Wax and copper
61 x 91.4 (24 x 36)
Destroyed

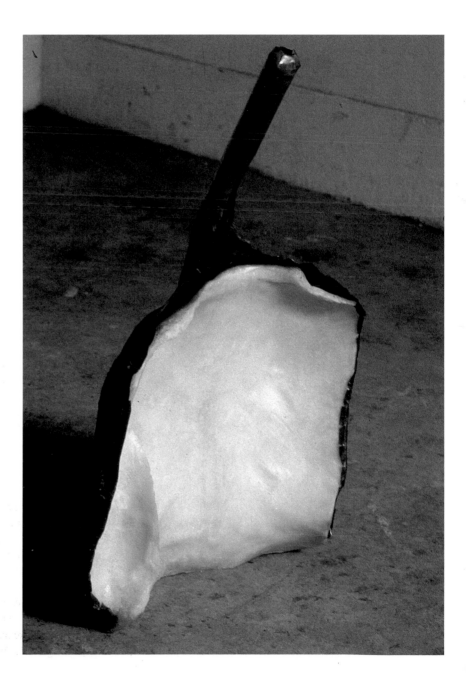

UNTITLED 1986 [5]
Shirt, hot water bottle,
coathanger and water
91.4 x 61 (36 x 24)
Destroyed

UNTITLED 1986 [6]
Pillowcase, hot water bottle,
coathanger and water
Destroyed

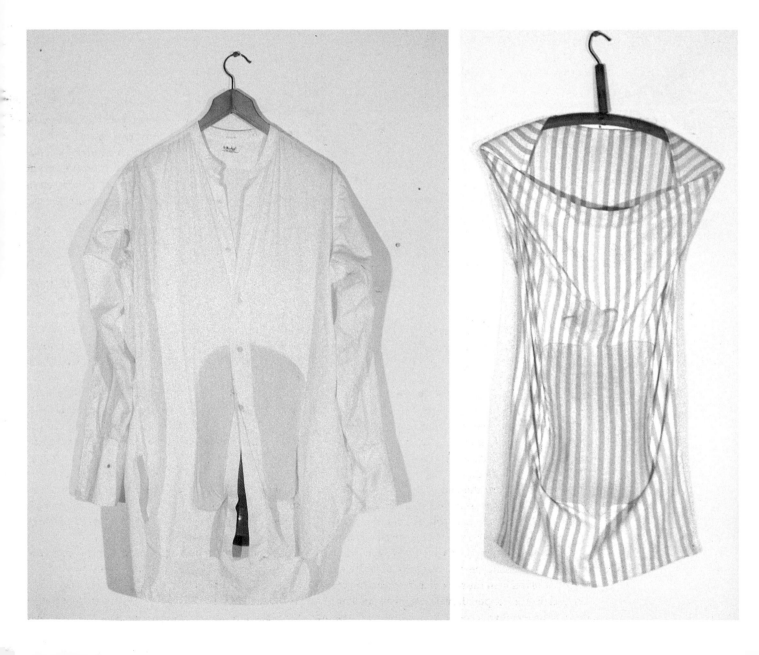

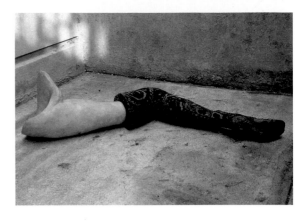

UNTITLED 1987 [7]
Wax, plaster and carpet
Private Collection

substitute for human flesh. A wax leg, jointed below the knee, was attached to a patterned prosthetic made from a worn-out rug (fig.7); a wax mould of her back was wrapped in a copper plate that looks like a protective piece of body armour as well as an implement for shovelling up the dead (fig.4). A photograph taken in her studio at the Slade shows the side of her head smothered in plaster as she cast the inside whorls of her ear. Whiteread was using her body as a living mould, wax-casting the space between her knees, under her armpits, across her back. She also fused everyday household objects with parts of the body, emphasising their symbiotic relationship – furniture describes our physicality by being made to fit it.

By 1987 and her MA show at the Slade, Whiteread had started to use hot-water bottles as a stand-in for human organs, their soft, rubbery exteriors fleshy and malleable. Warm and comforting when filled, they resembled deflated lungs when empty. She suspended one neck-down inside a granddad shirt on a hanger, positioned roughly where the bladder would be (fig.5). The mouth of the bottle hung just below the tails of the shirt, like testicles, the body of the bottle protected only by the thin cotton (as thin as human skin). A further hot-water bottle was sewn inside a pillow slip that she had cut to look like an apron, the bottle in a pouch at the front as if it were a womb, or a baby marsupial (fig.6).

When it came to the end of her two years at the Slade, Whiteread was unsure about showing her work. During her MA she had destroyed works such as the trap-like wardrobe, finding it too disturbing, and she chose to hang her final show in tucked-away places: the male and female hangers, initially called *Torso*, were hung on the back of a door, and the cast of her back in the copper shovel was positioned on the floor in the metalwork room. But even though she hid

her work from all but the most determined degree-show visitors, several influential people were excited by it. One was her Slade tutor Alison Wilding, for whom Whiteread went on to work as an assistant for a year after graduating. Another was Barbara Carlisle, who ran a small gallery in Islington, several miles from Cork Street in Piccadilly (which was still the centre of the commercial art world in London). On the strength of her Slade show, Carlisle offered Whiteread her first solo exhibition the following year, which was to include four new works: *Closet, Shallow Breath, Mantle* and *Torso*.

After leaving the Slade, Whiteread rented a studio in Wapping. Without the support of staff and fellow students at college, she soon realised that the work she made would have to be moveable and workable on her own. She was no longer casting from her own body, but used furniture as a stand-in for human presence. Chairs, tables, wardrobes, hot-water bottles, beds – all were created on a human scale for human use, and all carried the trace of past lives on their scuffed surfaces.

Whiteread started to use this single-casting method to make larger pieces, employing old furniture bought from junk shops and through the classified columns of newspapers as moulds. She searched underneath tables and inside cupboards for signs of wear and tear. Like a detective looking for clues of the object's past, she pulled prints from these unseen surfaces, filling objects with plaster and waiting for it to set before ripping off the furniture's frame to reveal a flaky white cast of the space beneath it.

The first work she made that was included in the Carlisle show was *Closet*, a plaster cast of the inside of a small wardrobe, covered in black felt (see p.18). Whiteread felt that *Closet* was her first proper sculpture, since it was the only one she had made that

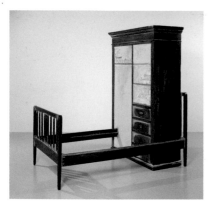

Doris Salcedo
UNTITLED 1995 [8]
Wood, cement, cloth and steel
195.9 × 190.2 × 126.1 (77 1/8 × 74 7/8 × 49 5/8)
Hirshhorn Museum and Sculpture Garden,
Smithsonian Institution, Joseph H. Hirshhorn
Purchase Fund, 1995

SHALLOW BREATH 1988 [9]
Plaster and polystyrene
18 × 191 × 93 (7 1/8 × 75 1/4 × 36 5/8)
Private Collection

didn't depend on the architecture of the space in which it was shown for support. Taking its cue from the simple architectural objects of the Minimalists, such as Carl Andre's controversial *Equivalent VIII* 1977 – 128 fire bricks that were stacked to form a long, slender platform in the Tate Gallery – this work stood unaided in the middle of the gallery floor.

Shallow Breath (fig.9), however, used the wall as a crutch. It was cast from a single bed, a basic piece of post-war utilitarian furniture with five slats stretched across the narrow frame to support the mattress. She cast the dark space beneath the counterpane, the underside of the base of the bed, which she had covered with thickly woven brown hessian, replacing the original thin fabric. As the plaster was poured onto the upside-down base it tried to force its way through the hessian, so that when it had set and the bed was pulled away, a layer of brown threads was trapped in the surface, resembling fine body hair. The fragile plaster surface and the imprint of the slats running horizontally across the surface gave the work the appearance of a frail old man, the title suggesting a pair of weak lungs hidden beneath a pale flaky rib-cage.

Whiteread's father had died of heart failure a few months before the Carlisle show opened, and *Shallow Breath* was made in part as a homage to him. In *Closet* and *Shallow Breath*, as in much of her later work, death is never far from the surface. These works represent a claustrophobic blocking-in of the spaces underneath and inside furniture (the body's substitute). But while they speak of death and past life, they are not specific. Unlike the work of Whiteread's contemporary, the Colombian artist Doris Salcedo (fig.8), these sculptures do not use personal items such as shoes or clothes to refer to particular men and women who have been killed. The objects employed

by Whiteread are utilitarian, generic things that belonged to a whole post-war generation. The loss she speaks of is collective rather than personal.

Whiteread's show at the Carlisle Gallery was autobiographical in origin, using objects that she remembered from her childhood. The four sculptures were all cast from items that could have been found in any small bedroom, furniture from a time already passed into history. But while these objects do have their own past, it is not specifically hers. The surface marks that linger in the finished pieces are archetypal to most old furniture. They suggest a shared sense of history. It could be our wardrobe that has become *Closet*, our bed that now leans against the wall, recorded and preserved as *Shallow Breath*. And even though *Shallow Breath* was made as a direct response to her father's death, its power of communication goes beyond the personal narrative that inspired it. We all sleep in beds, were conceived and born there, had fevers on the mattress and feared the monsters in the gloom below. A bed is as much a part of our everyday life as sleep, sex and death, all of which occur on its porous surface.

Two other sculptures completed Whiteread's Carlisle show. The first, *Torso* (fig.10), was a macabre cast from the inside of a hot-water bottle. In contrast to the use of this comforting object that she had made at the Slade, all allusion to warmth and security had been stripped away. The bottle had been flayed to reveal a grey plaster cast of the inside, the rubber pattern imprinted into the surface like pores, the shape swollen like a baby's belly, limbless and headless. The other work, *Mantle* (fig.11), was cast from a dressing table, its drawers filled with plaster then destroyed. These solidified internal spaces are stacked on top of each other, on either side of a solid plaster cast of the space where the sitter's legs would once

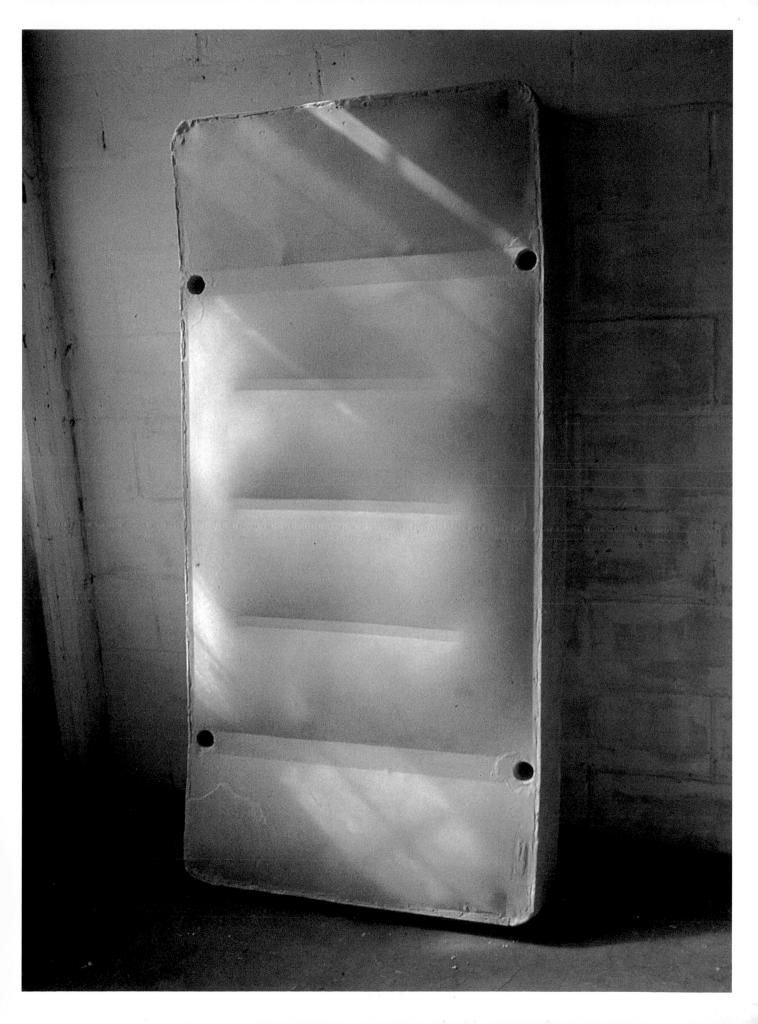

TORSO 1988 [10]
Plaster (white)
8.9 X 27 X 17.2
(3 1/2 X 10 5/8 X 6 3/4)
Private Collection

have been. The glass that covered the original table lies on top like the protective transparent shield over a museum exhibit, under which precious objects can be seen, except that in the case of *Mantle*, all that is visible is an imprint taken from the inside of the top drawers. The glass highlights these previously private, personal spaces that Whiteread has forced into the public domain.

Throughout 1988 and 1989, Whiteread continued to work with domestic furniture that evoked memories of childhood. *Yellow Leaf* (fig.12) was the cast of a table similar to the Formica-topped extendable one that her grandmother had kept in her kitchen. Its central leaf had been stored in another room, used only when the table needed to be lengthened for visitors. Whiteread cast her version with this middle section in place. For Whiteread, working alone in her studio, casting objects with which she was familiar connected her to her family. For the viewer, the everyday nature of the objects make the sculptures immediately accessible, communicating a shared sense of history, an irrecoverable past.

As if drawing on her initial training as a painter, the surface of each cast was vital to Whiteread, a register of the underside of the original object but also a canvas on which she could experiment. With *Yellow Leaf*, for example, Whiteread used cooking oil as a release agent, rubbing it on the underside of the table before casting to help intensify the traces of colour left behind in the plaster. *Yellow Leaf* was imprinted with dust, cobwebs, chewing gum and uneven screwheads, mute indicators of the hidden history of the table.

In 1989, Whiteread cast another table, calling the work *Fort* (fig.13). This was one of her last sculptures to include part of the original furniture within it: the slim drawer for table linen, now exposed, was full to

the brim with plaster. Increasingly her work relied less on the remaining trace of the original object, and more on the form and surfaces resulting from the casting process. *Fort* was a table, or more accurately the space beneath a table. With no room left to put your legs, it denies personal engagement. It is less like a table than a solid-walled garrison. There is no remaining sense that this was once a surface on which to share a meal. A place of discourse and communication is turned into one where entry is refused. Isolation and fear have replaced cosy round-the-table communality.

In the two years after Whiteread left the Slade, her work developed from simple casts of her body in wax to complex plaster structures based on everyday items that, through daily use, had become invisible. She turned tables into architectonic structures, recreated the psychological blackness of fear, and explored the under-the-bed syndrome. She started manipulating materials, no longer simply pouring lead into a spoon but building frames for bed bases and tables, dictating what was removed and what remained, experimenting with release agents and different types of plaster, drilling holes to ensure that the moulds were completely full, and destroying the furniture she associated with childhood.

MANTLE 1988 [11]
Plaster and glass
61 x 120 x 50.8 (24 x 47 1/4 x 20)
Private Collection

YELLOW LEAF 1989 [12]
Plaster, formica and wood
149.8 X 73.6 X 93.9 (59 X 29 X 37)
Collection Gulbenkian Foundation,
Lisbon

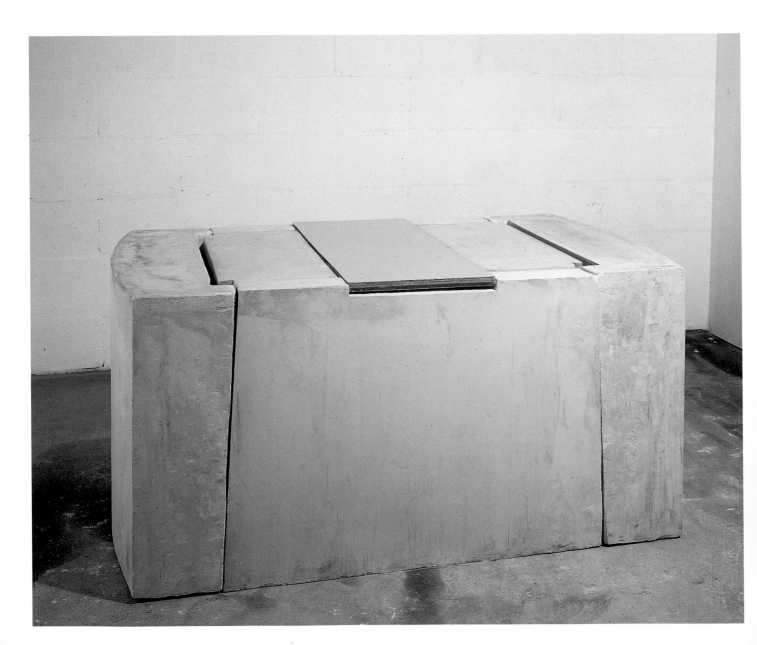

FORT 1989 [13]
Plaster and wood
90 X 130 X 74
(35 3/8 X 51 1/8 X 29 1/8)
Private Collection

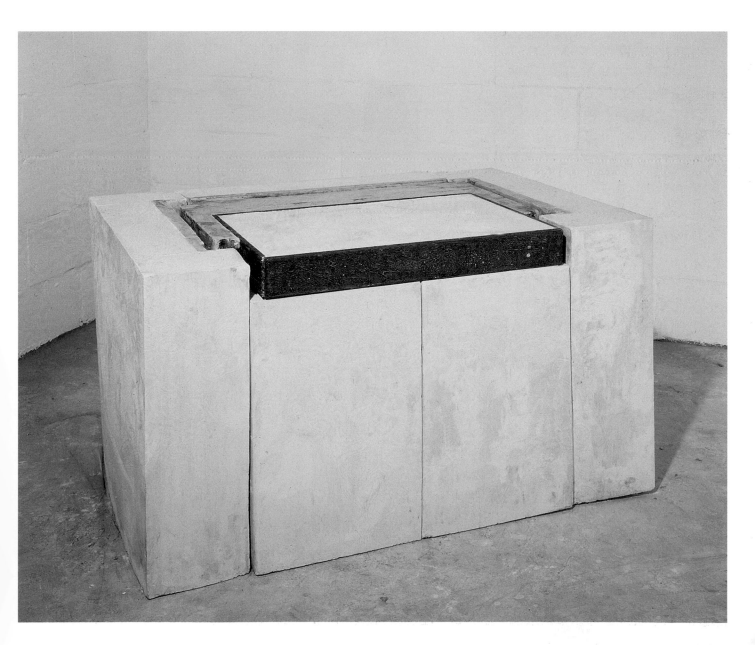

In 1988, a year after graduating from the Slade with an MA in sculpture, Whiteread completed *Closet*, a work she describes as her first real sculpture.

When I was at college it was very hard for me to make a sculpture for some reason. At Brighton Polytechnic I worked in the painting department. My work was on the wall, or leaning; there were a few floor-based things. When I was at the Slade the same thing happened. Occasionally I'd manage to get something to go on the floor, but it was always very small or almost insignificant. So I see Closet *as the first sculpture I ever made. It was a real breakthrough in a way, in that I made something that just went in the middle of a room. It was an object, you could walk round it. I was amazed when I finally managed to make something that did that.*

Since leaving the Slade, Whiteread had become increasingly interested in working with furniture, the objects that surround the body for its own use.

These were all very particular pieces of furniture – cheap, post-war furniture – which I somehow wanted to immortalise, to give it a kind of grandness. I was trying to make spaces that I was very familiar with, and that a lot of people would be very familiar with.

Closet was cast from a cheap wooden wardrobe, 160 centimetres high, its stained doors and walls stripped off after the inside had been filled with plaster and allowed to set. Only the five thin brown shelves that were layered symmetrically down the right-hand side of the wardrobe were left in place, now filled with compartments of solid plaster.

I used a very simple technique that, in essence, hasn't changed. I had a wardrobe, I laid it on its back, I filled it with plaster, then removed the wooden mould, and eventually covered it in black felt. This was a very crude method – something I could do in the studio on my own. I don't think my technique has really changed since, it's just that the technology I employ has become more complicated.

When Whiteread removed the doors and walls of the wardrobe, she was left with a pale plaster cast of the interior space. In future work this flayed interior would be left to stand just as it was cast, its vulnerable surface pock-marked with all the imperfections of the original object, stained with traces of varnish, paint and dye. But for this work, Whiteread chose to smother each plaster block – the tall central space that once held a rail of clothes, and the six cubes cast from between the shelves – in thick black felt. She vividly remembers the smell and sensation of the darkness she experienced as a child when one of her sisters locked her in their

grandmother's wardrobe. In *Closet* she succeeds in visually recreating not just the darkness of her memories but also the sense of palpable fear that total blackness invokes.

Originally Closet *was about trying to make a childhood experience concrete: I came to it from that angle. I was trying to think of a material that was as black as childhood darkness, which is fundamentally frightening because you don't know what's in that darkness. I was trying to use a material that would suck the life out of light. I looked at various things and black felt seemed to be the right material.*

The use of felt was also partly informed by my memory of sitting inside wardrobes as a child. My parents had this wardrobe that was full of clothes and boxes full of fabric. You could be in this place that was incredibly comforting and dark, totally surrounded by material. There would be a little chink of light, but essentially it was black, and it was totally enveloping. I wanted to make that experience tangible.

Looking at *Closet* is an uncomfortable experience. The black felt absorbs all the surrounding light, its dense surface wrapping tightly round each of the interior spaces, smothering it. The thick velvety reality of total darkness is rendered solid, recalling the sensation of not being able to see your hand in front of your face. The air inside the wardrobe has become a solid void, representing the heightened emotions of the child trapped within.

Since the early 1990s, Whiteread has given her works the most minimal of titles, referring to them as 'Untitled' followed by bracketed words pointing to the mould from which they were cast. But with *Closet, Mantle, Shallow Breath* and *Torso*, the titles were a metaphorical part of the sculpture. The word 'closet', for example, simultaneously brings to mind hidden, secret spaces, covert deals done in dark rooms, repressed ideas and psychological boundaries. The blackness of the sculptural *Closet* echoes the shady, manifold meanings of the word. *Closet* may stand exposed in the middle of a gallery rather than against the wall of a private bedroom, but its interior spaces are still impenetrable, locked away.

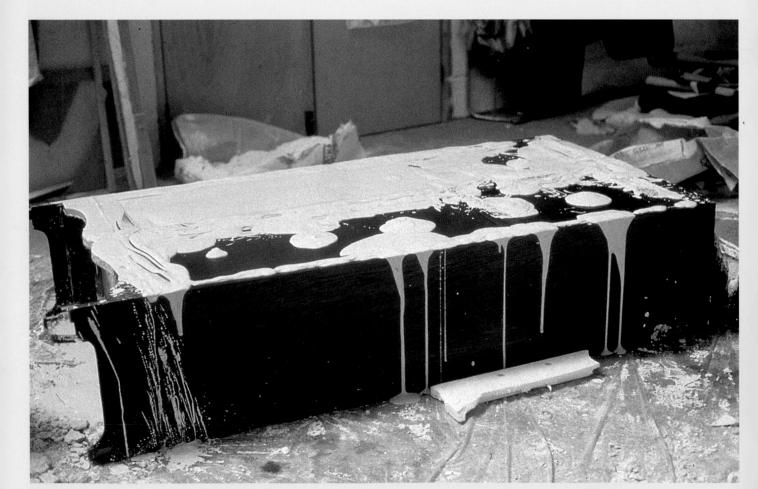

CLOSET 1988 [15]
Plaster, wood and felt
160 x 88 x 37 (63 x 34 ⅝ x 14 ½)
Private Collection

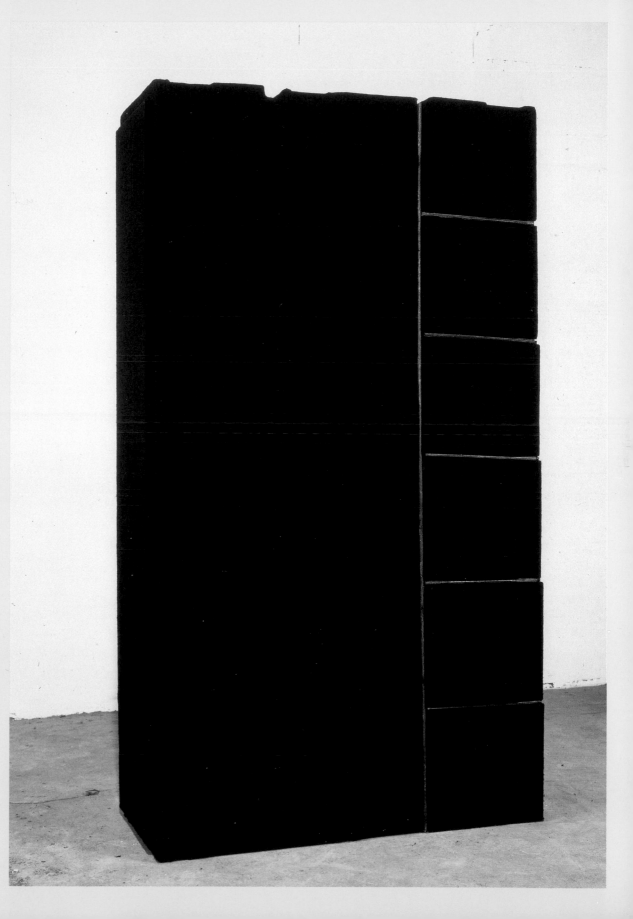

GHOST 1990 [16]
Plaster on steel frame
270 X 318 X 365 (106 X 140 X 125)
Private Collection

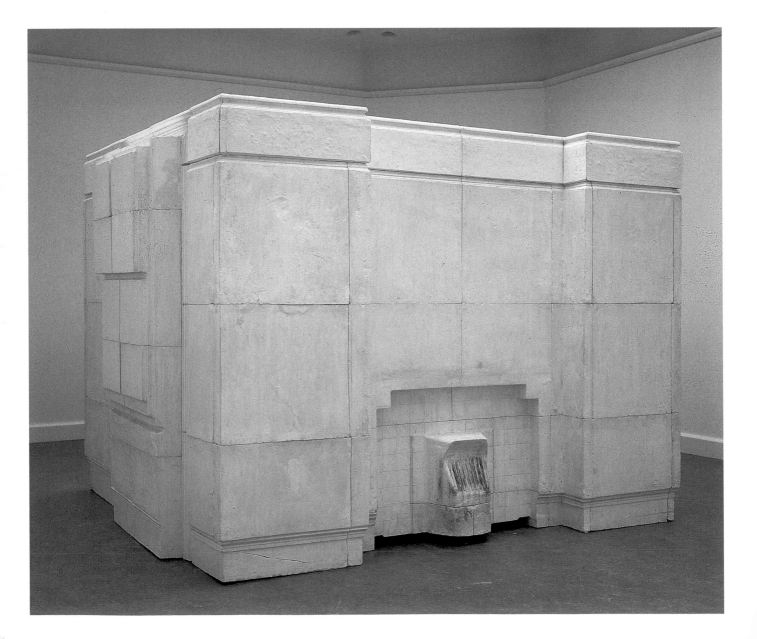

2

With her table pieces *Yellow Leaf* and *Fort*, Whiteread had moved from casting bedroom furniture to objects from other areas of the home. Simultaneously, she had her mind set on an altogether bigger project: the casting of a whole room. The result was *Ghost* (fig.16), which was exhibited at the Chisenhale Gallery, Bethnal Green, in 1990, and was bought by Charles Saatchi. When she set out with the idea to cast a room, she was still relatively unknown as an artist, but this work would put her on the shortlist for the 1991 Turner Prize.

While Chisenhale's director Emma Dexter was supportive of Whiteread's proposal, she didn't have the money needed to commission it. Whiteread had to apply for funding, writing on her application forms that she wanted to 'mummify the air in a room'. She received money from both Greater London Arts and the Elephant Trust, and the project became a reality.

The living-room she found to cast from was in a house at 486 Archway Road, a Victorian property that was about to be renovated. Located not far from where she grew up in Muswell Hill, its rooms were on a similar scale to those in her childhood home. Whiteread spent a month visiting the room every day prior to casting, deciding how she was going to tackle it. In order to work out the optimum panel size she should use to cast each section of the room, so that when it was reassembled it would have a sense of balance, of wholeness, she looked at the paintings of Piero della Francesca, an artist whom she greatly admired for his sense of composition. Her largest previous work had been the cast of a wardrobe, where plaster was poured into a mould on the floor. Now, she had to work out how to take casts directly from the walls, and ensure that she could remove them through the living-room door once they were complete. She also had to make sure that she could lift

them. She completed most of the panels for *Ghost* on her own over a three-month period, smothering the walls with thick clods of wet plaster, at one point blocking herself in as she cast the door.

At the time, Whiteread envisaged that *Ghost* would be exhibited for a few weeks at the Chisenhale before, in all likelihood, ending up in a skip. She didn't even really understand the full effect of what she was making until she assembled all the panels on a metal armature in her studio and began to grasp the level of disorientation that the viewer would experience. *Ghost* recreates the living room at 486 Archway Road, each panel revealing the shape of the walls, fireplace, window, door, skirting and cornice. But everything appears in reverse, inside-out, the deep skirting now a recessed frieze, the grid of tiles around the bulging fireplace indented. Whiteread realised, as she looked at the reversed light switch, that she had become the wall, looking onto the space that had once been inside the room and was now solidified. She had succeeded in her aim of mummifying the air in the room, of entombing the social space in which lives were once lived out. Visual reminders of those lives remained – the soot in the fireplace, the chips in the skirting board, the fragments of paint that had been absorbed into the plaster as it dried. But life itself was absent. The work is a spectral negative, an after-image of a room that no longer exists, a record that had been bleached of colour like an old photograph left out in the light. In a sense cathartic, *Ghost* is a mausoleum to Whiteread's own past, yet it speaks of a shared sense of loss, of memories bricked in and entombed.

When she was a teenager, Whiteread worked at Highgate cemetery in north London as a volunteer, helping to repair broken headstones and pillaged crypts. She clearly remembers the sensation of terror coupled with fascination when approaching a tomb

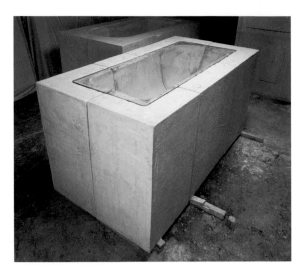

VALLEY 1990 [17]
Plaster and glass
95.3 × 185.4 × 96.5 (37 ½ × 73 × 38)
Private Collection

whose door was ajar, daring herself to look within, fearing to see the body she knew must be there. *Ghost* initially appears as if it has been hewn from solid rock, but as you walk around the sculpture, cracks appear in its solid armature and – rather uneasily – you are drawn to look between the panels, to see what lies inside. The flaky panels are like chalky white gravestones, with chinks of light appearing between them, pulling you closer to look into the tomb.

Ghost is not a solid tomb but a facade, a skin peeled away from a dying room, a death mask capturing surface detail, not substance. The fact that there is no ceiling, and that one can see through the sculpture to the metal scaffold within, doubly denies your reading of the sculpture as a room. Nothing is as it seems: not only is everything in reverse, but the seeming solidity of the negative room is also challenged. *Ghost* questions what a room actually is – is it the four walls, the ceiling, the door, or is it the life that is lived out within it? Is the room purely a container for social space, a place to act out lives, or does it – did it – have a physical presence?

Ghost was exhibited on its own in the windowless, warehouse-like Chisenhale Gallery. Whiteread's first significant show could not have been more different from the early commercial success of many others of her generation – Damien Hirst, Gary Hume, Fiona Rae, Ian Davenport. While they graduated more or less as a group from Goldsmiths College in the late 1980s, and exhibited together in an old Docklands building in the exhibition *Freeze* (a show often cited as the starting point for the Young British Artists), Whiteread was tenaciously following her own path. But she nevertheless joined Rae and Davenport on the Turner Prize shortlist in 1991.

In the accompanying Turner Prize exhibition she was represented by *Ether, Untitled (Amber Bed)* (fig.26) and *Untitled (White Sloping Bed)*, new works in plaster and rubber. Contemplating these sculptures was an uncanny experience: while your mind told you that you were looking at a bathtub, a bed, you were in fact looking at everything that these things were not. You were looking at solidified air from under a bath or a bed rather than the object itself.

Ether was the first of three bath pieces that Whiteread produced in 1990. It was made using an old cast-iron bath stripped of its enamel coating. The tub was placed in a rectangular mould of shuttering ply (a cheap builder's material that Whiteread chose for its particular wood grain) and plaster was poured in. As it began to set, the rust from the bottom of the bath was drawn into the plaster like paint in a fresco. When Whiteread saw these dirty orange stains, which clung to the plaster like scum in a bath, she felt the need to drill a hole where the plug would have been. It was as if a body had dissolved into the plaster, or had melted down the plughole. She had watched a news item earlier in the year that had shown ancient lead coffins being carried out of a church in Spitalfields, near to where she now lived. The bodies had liquefied and could be heard sloshing around, and experts discussed whether the plague could be released if they were breached. In *Ether*, the corporeal is again implied if not present, an allusion heightened by the body-sized scale of the work.

Whiteread's baths have little to do with their original hygienic use. The box-like shape of the mould that she used to cast the tubs gives the finished sculptures the look of sarcophagi, their generous proportions resulting in a sculptural solidity that suggests ancient stone. The sculptures were removed from the moulds chipped and flaking, as if they wore their long history on their sheer sides. Not since the late paintings of Pierre Bonnard, who repeatedly painted his wife in

UNTITLED (BATH) 1990 [18]
Plaster and glass
103 X 105 X 209.5
(40 1/2 X 41 1/2 X 82 1/2)
Private Collection

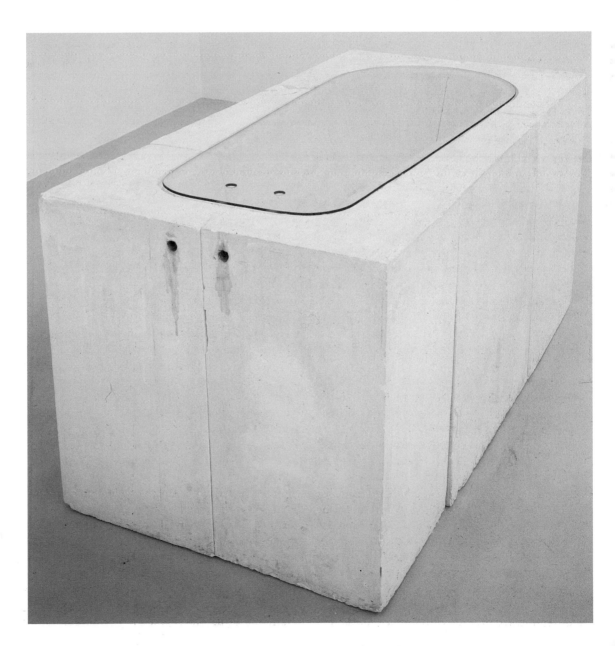

UNTITLED (AMBER MATTRESS) 1992 [19]
Rubber
111.8 x 92.7 x 109.2
(44 x 36 1/2 x 43)
Private Collection

the bath – her body at times dissolving under the dancing highlights of the water – had this simple domestic object received such attention.

In *Valley* (fig.17), the second bath piece, Whiteread added a sheet of glass to the top. It was reminiscent both of the open coffins used for leaders lying in state – she had recently visited Red Square in Moscow and seen the embalmed Lenin lying under glass in his mausoleum – and of the still surface of a lake. Perhaps Whiteread was also inspired by a picture of the Glacier Man in her studio, a 5,000-year-old preserved corpse found in the ice. But *Valley* was also suggestive of life, albeit accidentally. While plaster sets relatively quickly, a certain amount of time is needed to allow it to cure, or dry out thoroughly. Whiteread added the glass lid to *Valley* before this had happened, and returned to her studio the next day to find that a layer of condensation had formed on the inside of the glass, as if a person were lying in the hollow underneath, breathing, or as if the sculpture itself were sweating.

For the final work in this group, *Untitled (Bath)* (fig.18), Whiteread again added a glass lid, but this time drilled two holes in the top at one end, corresponding to a pair of holes that had also been drilled in the plaster, where the taps would have been. Rust traces had trickled down from the holes in the plaster like tears from eyes, while the circular openings in the glass – literally breathing holes for the plaster – appeared like nostrils.

At the heart of these bath sculptures lies a deep-rooted tension. Baths are associated with cleanliness and comfort, yet these works bring to mind sarcophagi and death; stains are all that remain of liquefied bodies that seem to have trickled away. A similar tension pervades all of Whiteread's early work, where familiar objects create a sense of security that is then purposefully yet discreetly undermined.

It was while creating the three baths that Whiteread pared down the titles of her works. While she wanted her work to transcend the specifics of the object from which it was cast, the title she gave to each piece suggested a particular way of approaching the sculpture. 'Closet' implied a secret, hidden space; 'torso' the reading of the cast as a body. 'Ghost' and 'ether' suggested ephemerality, a mere residue of what once was. 'Valley' referred to the steep sides of the particular bath she had used, along with the grey-silt colour of the resulting cast. It also alluded to the way in which the rock-like solidity and organic hollows in these works connect with the landscape. Now, however, Whiteread chose to stop providing clues as to how to interpret each piece. From this time on, all her works – with the exception of the *Torsos* – have been untitled.

In 1991 Whiteread returned to casting from beds, using both the bases and the mattresses, in works that became increasingly anthropomorphic. *Untitled (Amber Bed)* 1991, the first work she cast in rubber (see p.34), was slumped against the wall, its form furrowed like a plump belly. *Untitled (Amber Mattress)* 1992 (fig.19), followed suit, its surface stippled with cellulite, orange and fleshy. Even with her work in plaster, the body was ever-present – surface bubbles gave it the texture of bone, its colour like the pallid skin of a corpse; the dental plaster she later used was jaundiced or pink, and desiccated like dry skin.

Untitled (Yellow Bed) 1991 (fig.21) was painstakingly cast in dental plaster, a two-part work depicting both the space above the mattress and the area beneath the base of a narrow single bed. The 'base' is pinned to the wall by the rigid 'mattress', which had been covered in a loose sheet before casting, to leave wrinkles all over the surface like an old person's skin. Over this a yellow stain blooms, as if someone has

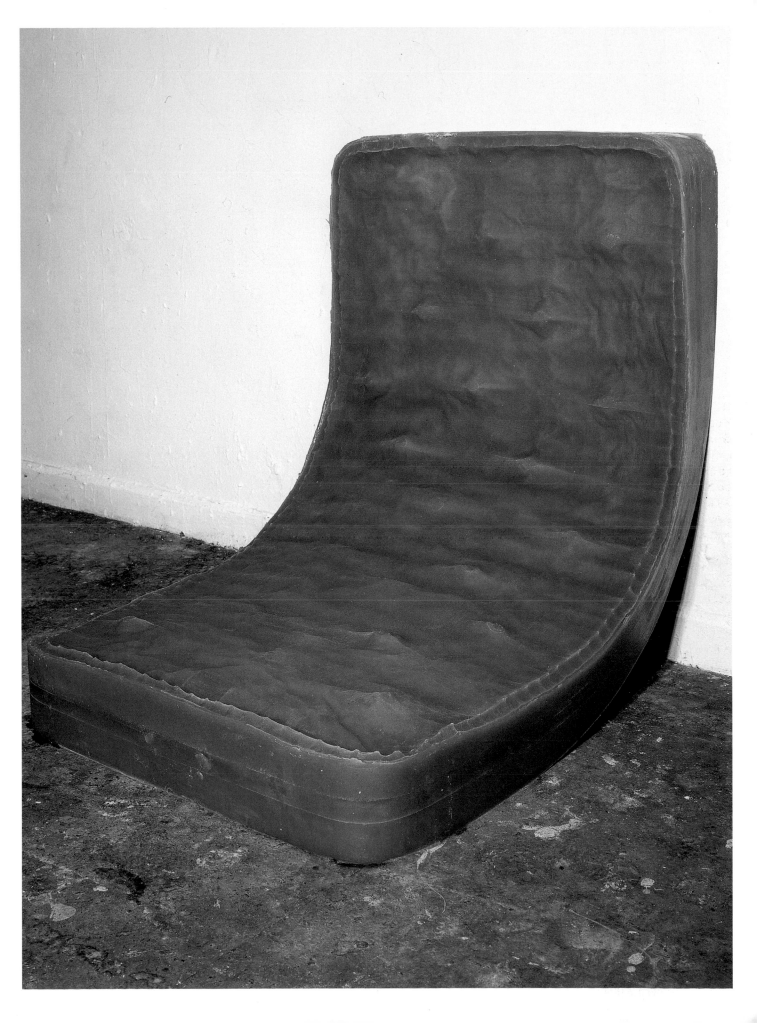

UNTITLED (AIR BED II) 1992 [20]
Polyurethane rubber
122 x 197 x 23 (48 x 77 ½ x 9)
Tate. Purchased with assistance from
the Patrons of New Art through the
Tate Gallery Foundation 1993

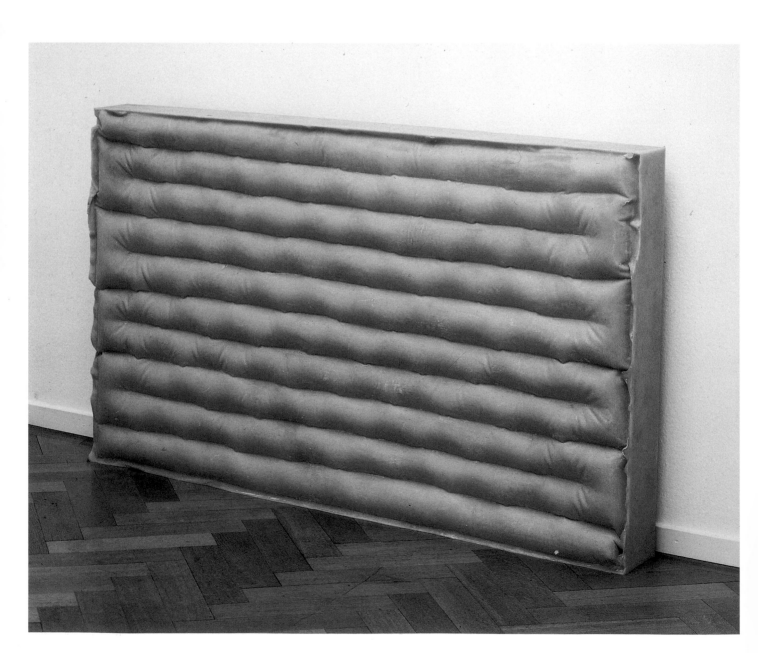

UNTITLED (YELLOW BED) 1991 [21]
Dental plaster
167.6 x 68.6 x 35.6 (66 x 27 x 14)
Hirshhorn Museum and Sculpture
Garden, Smithsonian Institution.
Museum Purchase, 1993

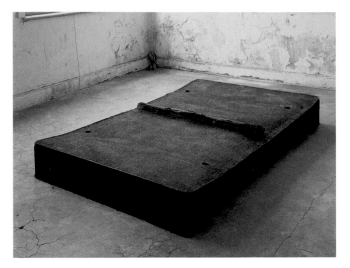

UNTITLED (BLACK BED) 1991 [22]
Fibreglass and rubber
30.5 x 188 x 137.2 (12 x 74 x 54)
Weltkunst Foundation, Dublin

UNTITLED (CLEAR SLAB) 1992 [23]
Rubber
198.1 x 78.7 x 10.2 (78 x 31 x 4)
Private Collection

wet the bed. *Untitled (Black Bed)* 1991 (fig.22), was cast from a folding double bed; a thin ridge protrudes down the centre where the thick tar-like rubber forced its way into the fabric hinge. While the blackness of the piece recreates the emotional sensation experienced when looking at *Closet*, the surface also resembles human skin, pock-marked and covered with short hairs, the central fold labial and protruding.

In a couple of bed pieces, Whiteread seemed to delve inside the body. *Untitled (Air Bed II)* 1992 (fig.20), a cast of the air inside a blow-up bed, is a positive rubber sculpture the colour of pickled organs in a laboratory. Forming a freestanding block, its bloated tubes resemble distended intestines, far removed from the air-filled original. It is as if the bed had gorged on those who slept on it, turning its insides solid in the process.

Sigmund Freud described the uncanny (or *unheimlich*) as 'the name for everything that ought to have remained ... secret and hidden but has come to light', and the term is therefore extremely apt in describing the disturbing nature of Whiteread's works. In many of her bed pieces, she played with the boundaries between animate and inanimate. They became substitutes for humans, propped up against her studio wall or curled in a corner. She endlessly photographed abandoned beds and mattresses she saw on the street that took on human attributes as they lolled, sprawled and lay comatose. This confusion between the animate and the inanimate recalls Pygmalion's dream in Ovid's *Metamorphoses*, where the sculptor falls in love with his own carving of a naked young girl, and eventually transforms her marble curves into flesh and blood through the power of Venus (his desire). Freud uses a modern reworking of the myth, E.T.A. Hoffmann's *The Sandman* 1817 (about a boy and his automaton), to explore the uncanny relationship

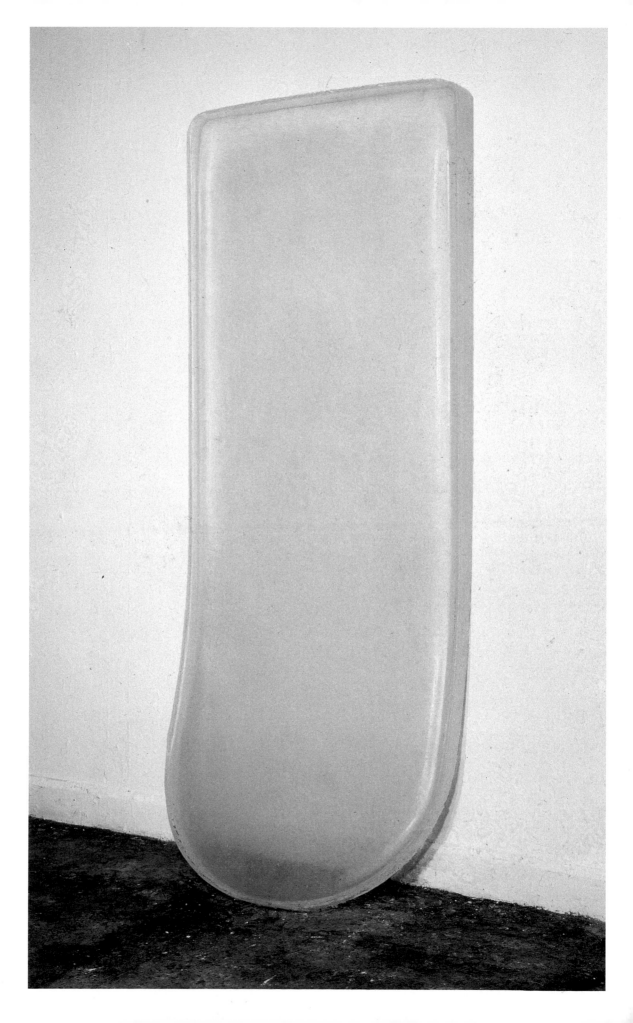

UNTITLED (SLAB II) 1991 [24]
Rubber
14 × 197 × 75 (5 ½ × 77 ½ × 29 ½)
Stedelijk Van Abbemuseum,
Eindhoven

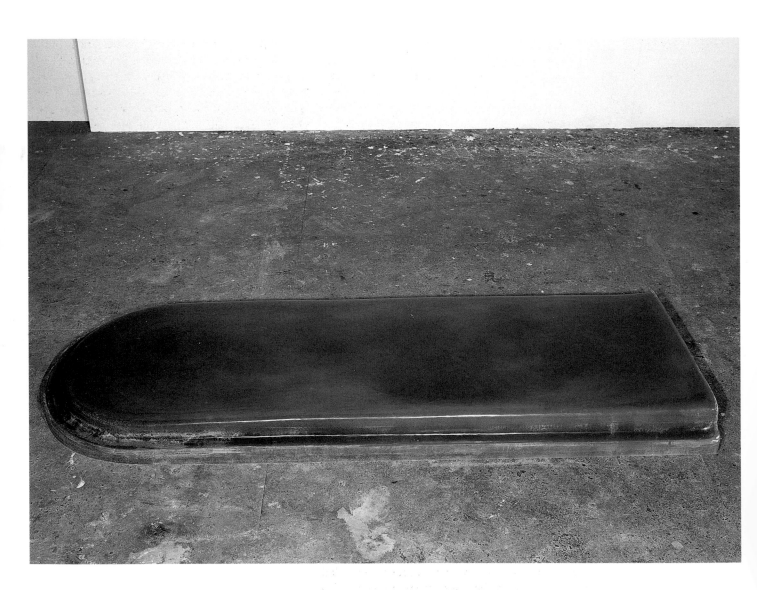

UNTITLED (TORSO) 1991 [25]
Dental plaster
8.3 x 16.5 x 23.5 (3 1/4 x 6 1/2 x 9 1/4)
Private Collection

between the inanimate and the animate. Whiteread's beds – made to fit human proportions – draw on a similar psychological uncertainty, where logic surrounding inanimate objects fades away to be replaced by the irrational fear that they have somehow come to life.

Whiteread also worked with other objects intimately linked to human scale. In the early 1990s, she frequently rummaged around in a particular architectural salvage yard in Dalston. One day she purchased a ceramic butcher's draining board, and asked if they had anything similar but larger. The owner took her to his other yard in Mile End, and she found what she'd been asking for without realising it – two mortuary slabs, covered in moss and algae. They remained untouched in her studio for six months until she decided to clean them, a task she found repulsive yet fascinating, likening it to cleaning a body. The porcelain surfaces were marked all over with shallow lines made by scalpels exiting bodies; a smooth groove ran around the edge of the slab to take away unwanted liquid from the corpse. When she cast from them, Whiteread decided not to use a release agent, to ensure that they would retain all the surface detail. She therefore had to wrestle the sculptures out of their moulds, and since the slabs are the shape of the body in its purest form, once cast in rubber they discreetly pointed to their original human cargo through their scale.

Untitled (Clear Slab) (fig.23) is like a giant tongue cast in milky white rubber and balanced on its curved end on the floor against the wall. It is lascivious and suggestive, the colour and opacity of semen. *Untitled (Slab II)* (fig.24), cast in amber rubber with a dark centre, runs along the floor. Its surface shines like viscous liquid, a pool of bodily fluids, like a liquefaction of the corpses that once rested on the slab.

By 1992, Whiteread's work was attracting interest from America and Europe. Her first commercial solo show in New York was held at Luhring Augustine, and one-person exhibitions of her work were also presented in public galleries in Eindhoven and Barcelona. At home, Charles Saatchi included her in his first exhibition, titled *Young British Artists*, alongside Damien Hirst and others. Whiteread's work at this time reflected her interest in everyday objects, and her desire to challenge the perception of things that others took for granted. With the *Slabs*, her work had become more abstract, yet it still resonated with human connections. The body was alluded to – despite being physically absent – in all her work, in the anthropomorphic parallels seen in the belly folds of mattresses and beds, in the shape of the finished *Torsos* (fig.25), and in her use of materials to suggest pasty flesh or bodily fluids. But increasingly she was moving away from such direct references to bodies, and beginning to look beyond domestic furniture to architecture, as a natural extension of her sculptural vocabulary.

One of the first pieces of furniture from which Whiteread cast was a bed (*Shallow Breath* 1988). It was no longer a bed on which you could sleep, since the mattress and sheets were long gone. The single bed base had been turned over so its four short legs stuck straight into the air, and it was boxed in with a shallow wood frame before plaster was poured in. Three years later, the fragile rigidity of plaster was replaced by an altogether more fleshy material: rubber. The first work cast in rubber was *Untitled (Amber Bed)*.

I wanted to make something figurative. It was a way of using the mattress, or the spaces underneath beds, as a metaphor for people. I've lived in London virtually all my life and having grown up through Thatcher's years, seeing the deprivation, and seeing more and more homeless people everywhere, I feel sad about what's happening here, about the state of Britain.

Old mattresses, bed bases, etc. are very much a part of London's detritus and you see them abandoned everywhere on the streets. I remember seeing a television documentary about a particularly run-down housing estate in Hackney, East London. As the documentary progressed you became increasingly aware of the degradation and poverty in which these people lived. An old blind man living on the estate reported a terrible stench coming from the adjoining flat. Eventually the council intervened and found a man who had died in his bed. He had lain there for two weeks and had sort of melted into his mattress. The corpse was removed and the council cleared his furniture onto the street with the intention of taking it to the rubbish tip. No one came to pick it up. There was this dreadful image of young children playing on the mattress that the old man had died on. I must have seen that film over ten years ago but the images have stayed with me and have possibly influenced me in some way. There are all sorts of stories related to the pieces I make. When you use second-hand furniture it's inevitable that the history of objects becomes a part of the work.

Whiteread has almost always used furniture or architecture with a history, and at the time she was making *Untitled (Amber Bed)* she was regularly advertising in *Loot*, a buy-and-sell newspaper, for specific items. After a time she stopped advertising because the people who owned the furniture would share endless stories and personal details with her. If she purchased her materials from second-hand shops instead, she could excavate the mute history of each object from the surface over time.

But *Untitled (Amber Bed)* is not remarkable so much for its specific history as for its use of materials. Up until this point Whiteread's work had been entirely plaster based. The limitations of this material were beginning to frustrate her – it was very fragile when cast, yet also heavy and cumbersome, and some works were impossible to move on her

own. She therefore decided to cast the bed base in rubber.

It was liberating to make a piece in rubber and to be able to bounce it around the studio without it breaking up; also to be able to find other ways of introducing colour.

Taken from the base of a single bed, *Untitled (Amber Bed)* was cast in a similar way to *Shallow Breath*, and when the rubber had set, Whiteread tried to prop it against the wall as she had done previously. But the flexible material wouldn't support its own weight; it slid down the wall, coming to rest with the bottom third flat against the floor, the middle of the sculpture creased like a stomach.

I kept seeing it out of the corner of my eye as I was working and it always gave me a shock, as if someone was just sitting there, or was slumped up against the wall.

The pale plaster had been replaced by thick orange rubber, and the bed base had been transformed into an anthropomorphic form, old and spent, propped up, an exhausted cast. It became the visual metaphor of London life for which Whiteread had been searching, a sculpture that not only had human qualities – the slight paunch, the two leg holes suggesting blank eyes on the world – but evoked the physical traces of a life lived out.

I used rubber that's a sort of fleshy orange. The material is very tactile and has a direct reference to our own corporeality. I then started working with a company that designed rubbers for me. I would have these bizarre conversations where I'd call up and request a rubber the colour of the first piss in the morning.

The beds she casts from are stained and old, the lives once lived on top of them reduced to blooms of yellow, orange and cream on the surface. The colour Whiteread selected for *Untitled (Amber Bed)* evokes the bodily fluids and memories that were once lodged in the fabric of the bed itself. But it is not only the colour that was carefully chosen. This sculpture – which bends and folds like an old mattress – was cast from a bed base whose underside was covered in fabric pulled tight over the slats. For *Untitled (Amber Bed)*, Whiteread replaced the old material with coarse hessian.

One reason I keep casting from beds is that I've found a surface that I can manipulate in a different way each time. I cast the space underneath a bed using the surface like a canvas – by sizing it in different ways, stretching it, getting it taut, I can completely control the surface.

In *Untitled (Amber Bed)*, the opaque rubber functions like flesh, its surface brittle and flaky as desiccated skin where the thickly woven material that Whiteread stretched over the slats of the bed has roughed it up. It is this fascination with materials and their unique properties that has threaded through all of Whiteread's work, long after her anthropomorphic interest in beds subsided.

UNTITLED (AMBER BED) 1991 [26]
Rubber
129.5 X 91.4 X 101.6 (51 X 36 X 40)
Musée d'Art Contemporain de
Nimes

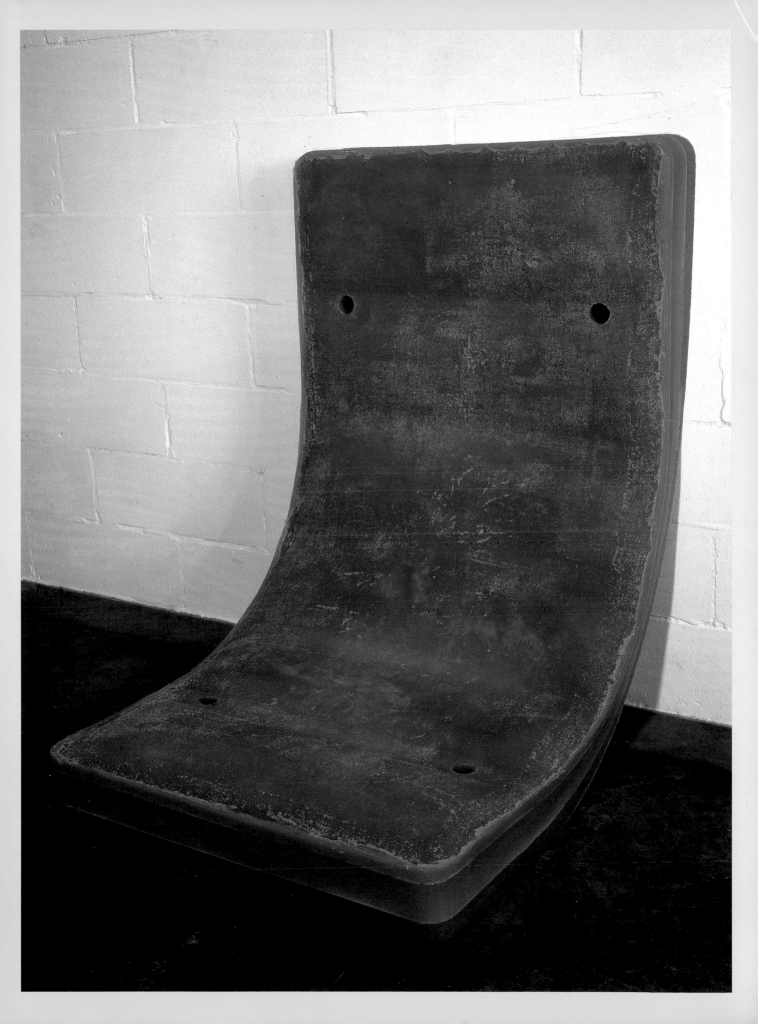

Photographs by Rachel Whiteread [27]
Clockwise from top left:
Skeletal House, Italy, 1996
Cappadocia, Turkey, 1999
Door, Turkey, 1999
Floor, Greece, 1994

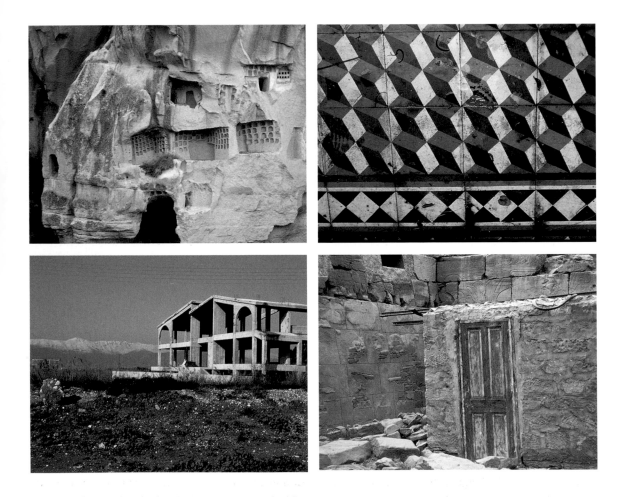

3

ARCHITECTONIC GHOSTS

Architecture is built on a scale that corresponds to the human form, but it is not as personal or specific as individual items of furniture. Wardrobes and dressing tables store our personal belongings, record our lives; beds absorb our dreams and fevers as we sleep. Within architecture's walls, on its floors and stairs, events may be played out, but the marks it acquires over time are incidental: dents in the floor from dropped toys; chips in doorframes from clumsy collisions; layers of different paints and wallpapers tracing changes in fashion. Whiteread's fascination with the architecture of space in *Ghost* marks a pivot in her sculptural thinking. For while furniture is specific, subjective, laden with memory, architecture plays itself out on a more public scale, and Whiteread's interest in its geometries becomes increasingly formal from this point on.

In *Ghost*, the walls of a room that had experienced 100 years of use were fingerprinted for evidence. Plaster, chiefly used by sculptors as an in-between medium for modelling before casting in bronze, had created an in-between room. It was a negative imprint in the gallery (itself a positive space), a solidified cast within the void of a larger room whose social space was still active, evolving, changing. Whiteread was not the first artist to present a room within a room. Post-Minimalist artists such as Louise Bourgeois and Bruce Nauman had installed rooms and corridors in a gallery context, challenging the experience of both the gallery and the architectural form. American artist Gordon Matta-Clark's slices of real buildings often found their way into the gallery environment. His short working life (he died in 1978 aged thirty-five) was spent examining space within domestic architecture, cutting holes through floors, carving wedges through house facades, bringing the outside into the heart of buildings, revelling in shards of negative space (see fig.28). He wasn't alone in examining the contrast between positive and negative space on such a large scale. Land artists like Robert Smithson, with his *Spiral Jetty* 1970 in Utah's Great Salt Lake, and Michael Heizer with his *Double Negative* 1969 – two huge trenches cut into the Nevada desert – also examined the visual power of the void.

Whiteread has studied Matta-Clark's work, which now exists chiefly in photographs and drawings. All his projects were temporary, as *Ghost* was initially meant to be. *House* – conceived only a couple of weeks after *Ghost* was exhibited – was also emphatically intended to be an ephemeral work. While *House* now exists in endless photographs and newspaper cuttings, in Whiteread's drawings and video footage, the actual physical experience of standing on the pavement in Grove Road, in the East End of London, and facing a pale concrete cast of all the spaces that a family once privately inhabited, can never be recreated (see p.50).

Photography as a record both of her own work and of contextual areas of interest is vitally important for Whiteread. Since 1991, when *House* was still just an idea, she has used a camera as if it were a sketchbook to document architectural structures. She has photographed skyscraper facades and the gaps between buildings in New York; concrete frames of unfinished houses and ancient steps in Turkey; metal construction grids and condemned tower blocks in the East End of London. Dozens of boxes in her studio contain images of windowless houses, external staircases and canals cut through cliffs. Frank Lloyd Wright's Falling Water, a house built over a waterfall, features in her collection and epitomises her long-standing interest in the play between positive and negative space, as do her photographs of marble *trompe l'oeil* floors from Italian villas, where depth is implied but is illusory.

In 1992, Whiteread cast her first floor. In contrast to the *trompe l'oeil* floors, depth was given where none was expected. For Whiteread had cast not the surface of the floor, but the hidden volume underneath it, the secret space between the joists that support the wooden floorboards. The idea to cast a floor came when she was asked to create a new work for Documenta IX, a vast exhibition of international art held every five years in Kassel, Germany. Aged twenty-nine, she was one of the youngest artists participating. She spent days in the gallery she had been allocated, familiarising herself with the specific architecture of the Fridericarium. Whiteread has often been called a geographer of hidden space, and initially her idea was to map the whole room, recreating the floor in the first-floor gallery as if it were a fitted carpet. But after studying it she felt this was too fussy, and instead decided to invent a floor of her own to show there.

Cast in plaster, *Untitled (Floor)* 1992 (fig.31) is rectangular, with two missing square sections at opposite ends, as if these parts of the floor had been removed (as Matta-Clark did with the corners of a clapboard house in *Splitting* 1974, fig.28), or that the floor had originally been laid around cupboards or external pipes. It was 25cm deep and lay in 8 long rows, each plaster block separated by a narrow void the width of the original joist. The heavy imprint of wood grain ran perpendicular to the rows, a cobweb of swirls and knots pressed into the plaster.

While floors necessarily feature in every building, they are rarely scrutinised. Even the Italianate *trompe l'oeil* floors are merely a clever skin stretching across joists, hiding what Whiteread has described as the 'intestines' of a property. With this work, however, the floor became the centre of attention. But it was not a surface to be walked on; while the pattern of floor-boards was still visible, the raised level of the slim rows and the alternating voids and plaster beams would not sustain even mental footsteps. Whiteread had succeeded in disorientating the viewer once again, challenging our understanding of what a floor was, and what it could be.

Carl Andre's works may have given Whiteread the confidence to put white plaster blocks in the centre of a gallery, and to create her own floor pieces, but she didn't directly address his series of metal floors until 1999. *Untitled (Floor)* is more evocative of a performance piece by Vito Acconci called *Seed Bed* 1972, in which he lay under a false floor in a commercial gallery and masturbated while visitors walked overhead. Both deal with hidden space, a space of secrets.

Whiteread's floor for Documenta IX was the first work in which she had fabricated the shape of the sculpture. She had created the two indents to allow viewers to get close to the work, to get inside it and scrutinise the surface. She had determined the size of the piece and its shape. But it still had a degree of authenticity – it was cast from second-hand floor-boards, the height of the sculpture dictated by the height of the original joists. It would not be until the following year that she would become bold enough to cast a sculpture from an object entirely of her own making.

Whiteread cast several more floors and related works in 1992. In *Untitled (Wax Floor)* (fig.29) she took a slim cast the depth of a floorboard from a corridor, the tan-coloured wax taking an imprint of the grain as if it were a death mask. As Roland Barthes wrote in his influential book on photography *Camera Lucida* 1980, a death mask necessarily underlines death while trying to preserve life, a quality that can also be applied to the photograph. The vast majority of Whiteread's work can only be created at the

Gordon Matta-Clark
SPLITTING 1974 [28]
Colour photograph
68 x 99 (26 ½ x 39)
Courtesy David Zwirner
Gallery, New York

UNTITLED (WAX FLOOR) 1992 [29]
Wax and polystyrene
28 X 100 X 465 (11 X 39 3/8 X 183 3/8)
Eindhoven Museum

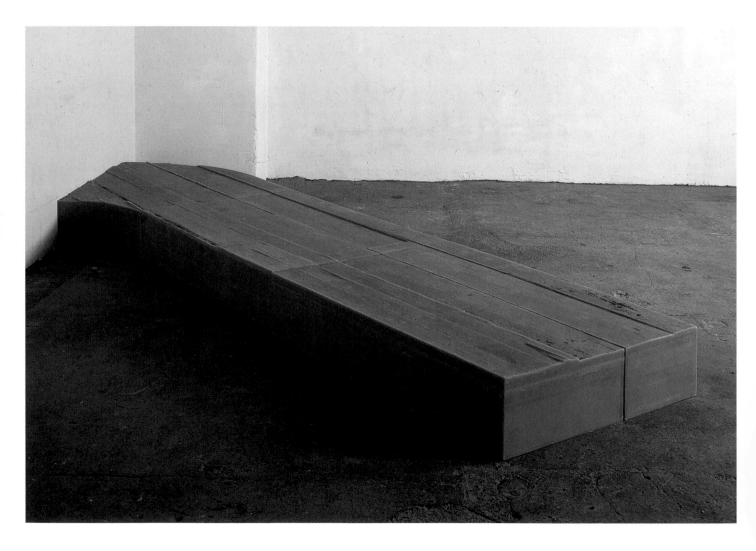

UNTITLED (AMBER FLOOR) 1993 [30]
Rubber
2 x 86 x 245 ($^{7}/_{8}$ x 33 $^{7}/_{8}$ x 96 $^{1}/_{2}$)
Private Collection

UNTITLED (FLOOR) 1992 [31]
Plaster
24.1 X 280.7 X 622.3
(9 ½ X 110 ½ X 245)
Private Collection

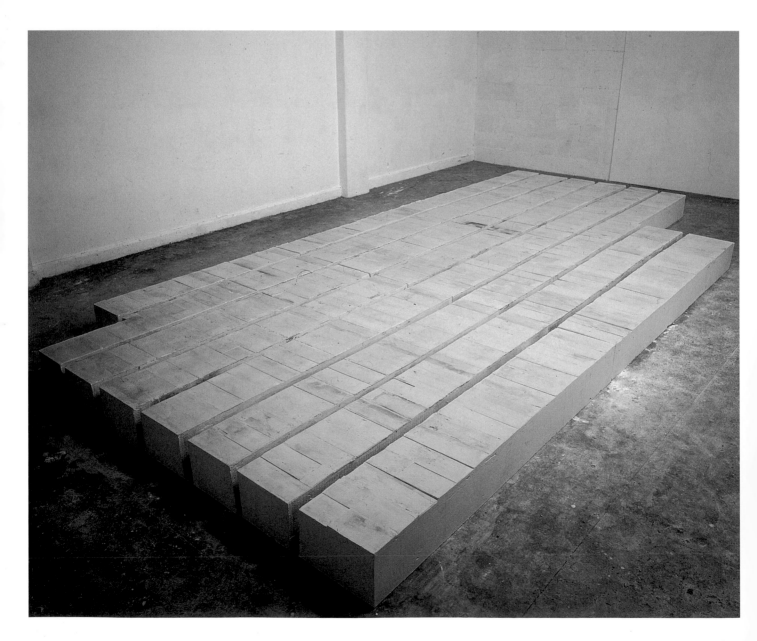

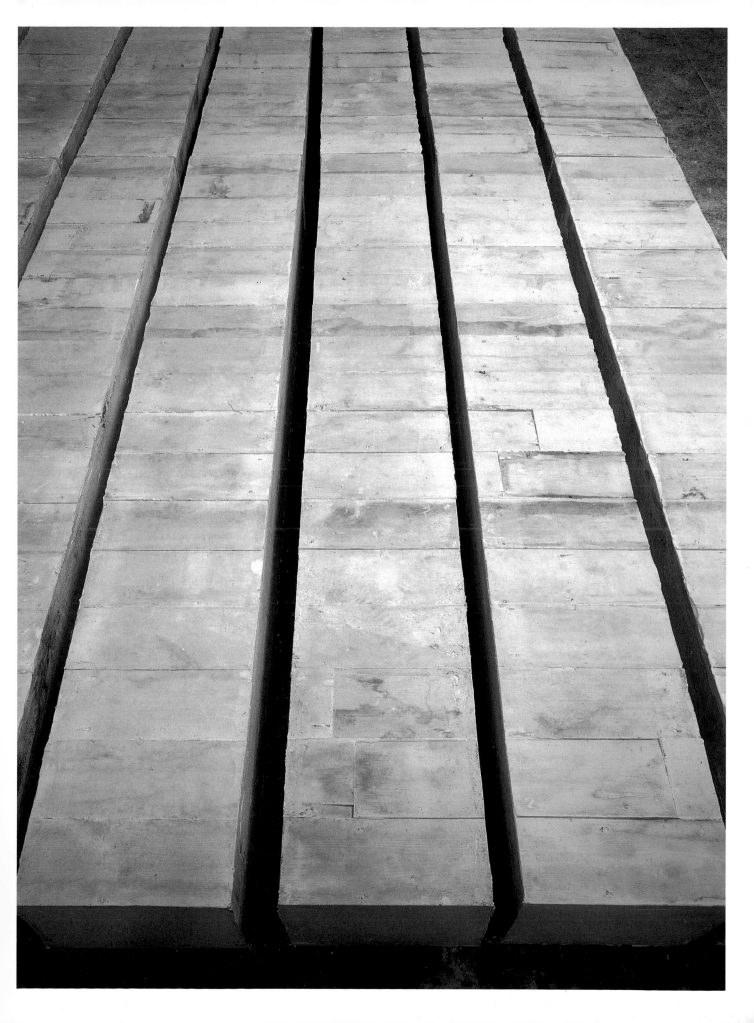

Study for FLOOR 1992 [32]
Brown ink and correction fluid
38.2 x 28.6 (11 7/8 x 11 1/4)
Private Collection

UNTITLED (FLOOR/CEILING) 1993 [33]
Resin and rubber
Two parts, 12 x 140 x 120
and 2.5 x 140 x 120
(4 3/4 x 55 1/8 x 47 1/4
and 1 x 47 1/4 x 55 1/8)
Tate. Purchased 1993

expense of the object – a floorboard, a table, a room, a house. Her sculptures document the history of the object up to that moment, but only by destroying its future life. The cast, just like the photograph and the death mask, records a moment that can never occur again; the present has become the past and the future will not, cannot, alter this snapshot of time captured.

Whiteread extended her series of floors to include casts of platforms that she constructed from old floorboards. She also made *Untitled (Floor/Ceiling)* 1993 (fig.33), a double cast of a floor and ceiling, with the ceiling rose indented in the middle of an orange rubber block. But increasingly she became preoccupied with drawing, and was given the opportunity to explore this more fully when she was awarded an eighteen-month DAAD International Artists' Exchange Scholarship in Berlin.

Whiteread moved to Berlin in the spring of 1992, temporarily abandoning her exploration of British history as exemplified by its furniture and domestic architecture. Now, Berlin took London's place as her sourcebook. On her arrival she felt an acute sense of grief and horror concerning Hitler's years in power, and travelled to concentration camps, watching how German and foreign visitors dealt with the overwhelming emotions that surfaced. At the time, a labyrinth of Nazi bunkers had been discovered underneath Berlin, and a debate was in progress as to what to do with them. In the end, in a strange parallel with Whiteread's work, they were filled with concrete to prevent them from becoming a shrine for Neo-Fascists. But Whiteread had wanted them to be blown up or dug out – in her mind, this series of linked, solidified rooms under the city centre had the potential to remain a powerful buried symbol of the Nazi regime.

Although she was given a studio at the DAAD

Foundation as part of her scholarship, much of her work during her stay in Berlin was completed in her flat in Charlottenburg, where she began by making drawings of the parquet floor (fig.32). Using correcting fluid over thin ink lines, and often finishing them off with watercolour, Whiteread constructed these layered and painterly drawings from the new environment around her. Frequently working on graph paper, she used the minimalist grid to underpin drawings that became white approximations of three-dimensional voids. The correcting fluid, a manipulable liquid that would set to form a hard opaque surface, functioned in a similar way to the plaster she had used for her sculptures.

Unlike many sculptors' two-dimensional works, most of Whiteread's drawings are not sketches for future sculptures. During the three years it took to make *House*, she did create hundreds of related drawings – of house-shaped correction-fluid drawings or doctored photographs of terraced houses with individual properties blanked out – but almost her entire output during her time in Berlin constituted works on paper not directly related to any forthcoming sculptural project. These grew from her exploration of the city: the line where the Wall had been until 1989; the endless faceless apartment blocks of former East Germany; the grid-like facades of former West Berlin's hotels and office blocks. But, while her final exhibition at the DAAD Gallery in 1993 comprised only drawings, she did create one major sculptural piece during her scholarship.

Untitled (Room) (fig.34) was a critical response to the architecture Whiteread found around her. This was the first sculpture that she had made from a structure entirely fabricated by herself. Unlike *Ghost*, it was not a cast of a room, but a cast of an object that resembled a room. The whole mould was

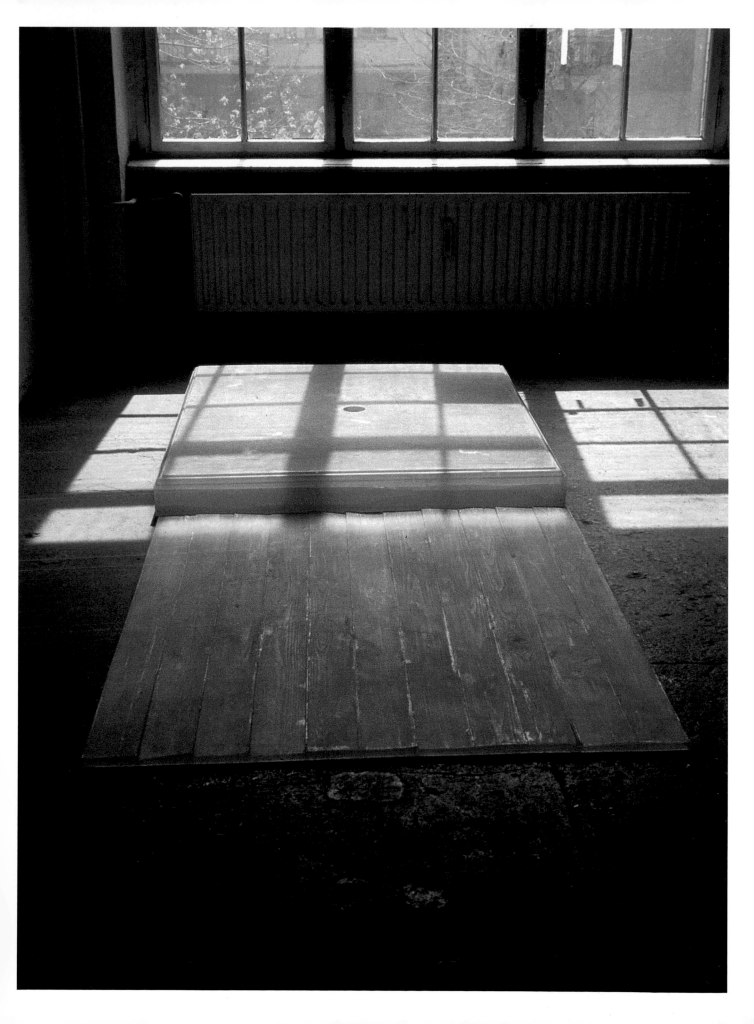

made within her Berlin studio, constructed out of cheap plywood sheeting, the window unopenable, the window frame unpainted. It had a basic low skirting board, but no other wall ornamentation; the door was unpanelled, with only a simple indent left where the handle should have been. Built to the dimensions of a basic modern room – which uses the arm span as a proportional tool – it was wholly faceless and without history, a superficial simulation of a room that existed solely to be destroyed.

When Whiteread had finished making the mould – which from the inside resembled a room but from the outside looked like a stage set, with the walls visibly bolted together – she set about preparing it for casting. There was no trace of history to capture in the plaster's responsive surface, no soot in the fireplace, and no fireplace either. She didn't have to pull cupboards off walls, or strip wallpaper, board up the windows or plug the cracks. There were no electrical circuits to disengage, no door handles to remove.

The resulting sculpture, although of comparable size, stood in complete contrast to *Ghost*. In *Untitled (Room)* the walls were sheer and mute, the panels cast in such a way as to suggest solid blocks of stone, not a crumbly facade. The release agent used had pulled colour from the ply into the plaster, but instead of suggesting layers of history it looked like the beginnings of damp, a subtle mottling above the window frame and over the walls. This had never been a home; it didn't even look like a habitable place. It was like a visualisation of the concrete cells described by J.G. Ballard in his dystopic novel *High-Rise* 1975, where people hopelessly attempt to personalise the symmetrical rooms up and down a forty-storey tower block. It also resembled one of Le Corbusier's 'units for living in', part of his grand plan to create 'House-machines' in the 1920s. He described these soulless mass-produced houses as 'healthy and beautiful in the same way that the working tools and instruments that accompany our existence are beautiful'. Whiteread's work was a riposte to the modernist dream, a sharp look at the reality of faceless existence. She described *Untitled (Room)* as a 'unit designed to survive in', but survival itself was even brought into question – there was no light-switch, no heat, no way out.

Ghost verges on the nostalgic, with its traces of past life embedded in its walls, an example of what the nineteenth-century German philosopher Friedrich Nietzsche described as man's need to cling to the past: 'however far or fast he runs, that chain runs with him'. But *Untitled (Room)* has no such chain. In part a response to the architecture that surrounded her during her time in Berlin, it was also as if temporarily moving to Berlin allowed Whiteread to take a step back from her own life. For while much of her work up until 1993 was rooted in autobiography, *Untitled (Room)* stood clear of any such reading. It was a *tabula rasa*, a clean sweep, free of memories and emotion. It was a blank canvas, the visual and mental foil to *Ghost*. And, as it turned out, to *House*.

Untitled (Room) was first exhibited at the Tate Gallery in the autumn of 1993. On the strength of Whiteread's 1992 solo show at the Stedelijk Van Abbemuseum in Eindhoven, and new work presented at the Sydney Biennale and Galerie Claire Burrus in Paris, she had been nominated for the Turner Prize again. But by the time the prize was awarded, Whiteread was already receiving far more media attention than the other three shortlisted artists (Hannah Collins, Vong Phaophanit and Sean Scully). On 25 October, *House* – her most ambitious sculpture to date – was unveiled. It was to dominate the press for the duration of the Turner Prize.

UNTITLED (ROOM) 1993 [34]
Plaster
275 X 300 X 350 (108 ⅛ X 118 ⅛ X 138)
The Museum of Modern Art, New
York

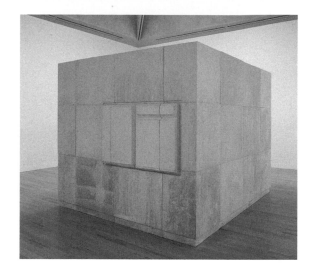

J.G. Ballard described the tower block in *High-Rise* as a body, the lifts pumping up and down like a giant heart, people like blood cells in arterial corridors, the ventilation system breathing for its inhabitants. Whiteread refers to the individual components of a house in a similar way: the space under the floor as the intestines, the walls as the skeleton, the electrics and plumbing the nerves and arteries. But in *House* the skeleton has been broken away, the everyday functions halted, the interior of the body filled up and sealed. The windows were vacant eyes, now blinded. The sense of protection afforded by a house, from within which we can gaze onto the world, has been denied. As Jean-Paul Sartre said in *Being and Nothingness* 1943, 'the bomb which destroys my house also damages my body in so far as the house was already an indication of my body'.

As if excavated at Pompeii, *House* was a solidification of the social spaces of an entire building. Since it had been three years in the planning, it related closely to *Ghost*. It was riddled with history, fragments of the past embedded in its pale grey surface like fossils. But *Untitled (Room)*, simultaneously exhibited in the Turner Prize exhibition, was everything that *House* was not. *Untitled (Room)* was to represent a significant step, signalling Whiteread's increased interest in form and composition, which was later to be explored further in her sculptures cast from tables and chairs. But in 1993, *Untitled (Room)* was overshadowed by the publicly sited *House*, which continued to dominate the headlines even after Whiteread became the first woman ever to win the Turner Prize and *House* was destroyed on 11 January 1994.

48 **49**

On 25 October, 1993, a small group of people gathered on a piece of featureless parkland in East London to celebrate the completion of *House*, Whiteread's largest and most ambitious work to date. It was her first public sculpture, and over the course of the next three months it was responsible for transforming her from a relatively unknown promising young artist to a household name.

The idea for *House* had first arisen three years earlier, a few weeks after she had completed Ghost.

House *was a continuation of my early work from the late 1980s, like* Yellow Leaf *1989 and* Closet *1988, where elements of the originals became an integral part of the work. When making* House *we cast a concrete skin throughout the whole building – casting around the wooden stairs and floors.*

Initially Whiteread obsessed over how to cast a whole house without destroying it, as she had previously managed to do with the room in *Ghost*. But when she teamed up with art facilitators Artangel, the idea of using a house due for demolition was presented to her. A giant cast of the inside could be made, with no requirement to preserve the building. The problem then became one of finding a suitable condemned house to use as a mould. For more than two years Whiteread scoured London for suitable properties. She came close to using a building on the proposed site for the controversial new M11. A fake blue heritage plaque, which had been attached to the property, read: 'This house was once a home.' But she finally settled on 193 Grove Road, a Victorian terraced house in Bow, where the tenant – Mr Gale – had refused to move out when the rest of the street was cleared to make way for a park. Eventually he was persuaded to vacate the property, and Bow council granted Whiteread access to the house to enable her to create a temporary sculpture from it.

This was a semi-derelict house in East London and I was very clear that it had to be in an area I was absolutely familiar with, and a building that was going to be knocked down. Grove Road was on a green corridor with a view to Canary Wharf, one of Thatcher's troubled economic babies, originally envisaged as an urban utopia.

On 2 August 1993, with a team of engineers, construction people, assistants and student volunteers, Whiteread set to work preparing the inside of the property for casting.

The previous tenants were obviously DIY fanatics. The house was full of fitted

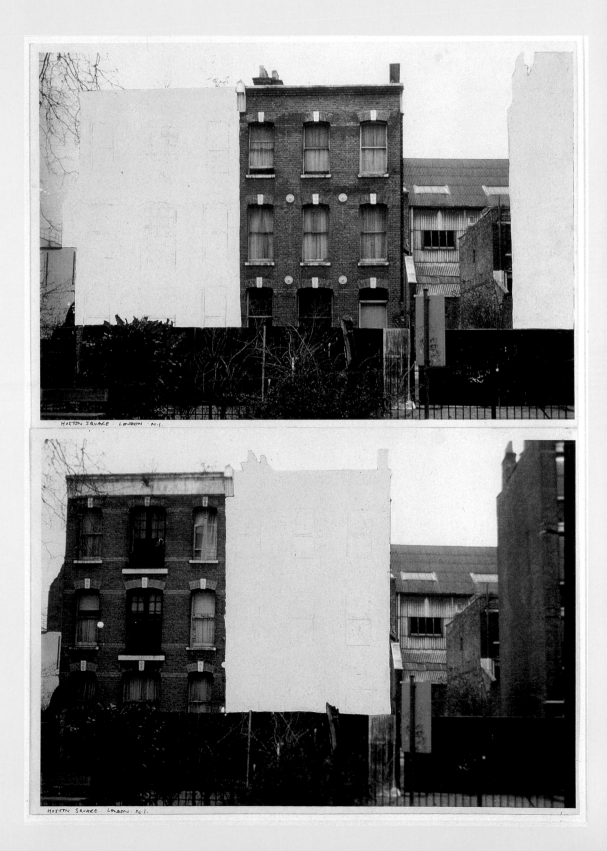

cupboards, cocktail bars and a tremendous variety of wallpapers and floor finishes. I was fascinated by their personal environment, and documented it all before I destroyed it. It was like exploring the inside of a body, removing its vital organs. I'd made floor pieces before in the studio, and had always seen them as being like the intestines of a house, the hidden spaces that are generally inaccessible. We spent about six weeks working on the interior of the house, filling cracks and getting it ready for casting. It was as if we were embalming a body.

To build a building within a building, we had to make new foundations. We worked meticulously on the interior, stripping it to its carcass. Then we applied a release agent, sprayed one centimetre of top-coat concrete [Lockrete, used to 'retouch' the white cliffs of Dover] over it, put the metal armature in place, and heavy-filled it with the rest of the concrete. It was a very strange place inside, like a cave or grotto. We used that process throughout the whole building; essentially the building became a mould. Then we stripped the whole thing by hand – every brick, every fireplace, and every door. When we'd finished casting, we got out through a four-foot square in the roof. The construction people said that it could just be patched over with wood, but I insisted that it had to be cast so that it would be a completely sealed space.

It took over a month for the interior of the whole house to be cast, and a further ten days for the concrete to cure and set. Then scaffolding was erected around the outside, and Whiteread and her team began removing the exterior of the building.

As we stripped away the building, it was amazing to me how much detail the casting had picked up, like Ghost *but much more substantial, not just because of its size, but because of the material and the brutality with which it had been made.*

The interior volumes of the family house had been solidified, and as the bricks were pulled away, sheer concrete walls imprinted with the idiosyncrasies of 100 years of domestic use were revealed. Soot clung to the bulges that protruded where fireplaces had once been; lemon paint from a top-floor bedroom clung to one wall, recalling a damaged fresco. Flexes that had once supplied electricity to switches had left their mark as tiny recessed spaces embedded in the concrete skin; the light switches themselves had been reversed and rendered unusable. The social spaces that had once been privy to secrets and arguments and love and despair had been petrified, making amateur archaeologists of the onlookers, who could only reconstruct the past uses of each room and stairwell from the tiny fossilised fragments that were left, captured in the concrete like prehistoric mosquitoes in resin.

Whiteread and her
assistants working on
HOUSE, 1993 [36]

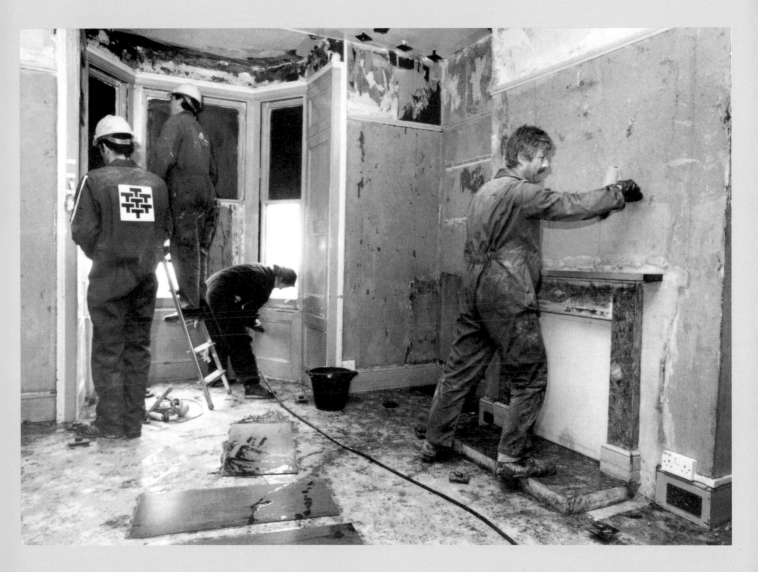

House was in fact the inverse of a house. All that had been air was now solid; few things that were solid had remained (only the staircases and the wooden floors were left in place, because Whiteread couldn't find a way to cast the house without them). It was an uncanny sculpture, having the proportions of a house, replicating the window frames, the doors, even the lean-to extension at the back, but in fact presenting everything in negative; fireplaces were now protrusions, window-frames like shallow crosses etched into the surface. *House* offered no way in, and – significantly – no protective roof over your head, since Whiteread had chosen not to cast the attic space. Instead it had a flat top cast from the upper-floor ceiling, and *House* appeared as a white-walled modernist pile, created from a Victorian terrace that was riddled with the woodworm of history.

During the two-and-a-half months that *House* stood silently on Grove Road, it generated an unrelenting storm of media noise. Over 250 newspaper and magazine articles were written about it, and it was debated everywhere from the House of Commons to the back of black cabs. Tabloids and broadsheets across Britain carried pictures of it on their front pages; the local paper the *East End Advertiser* ran stories every week, from the vox pop 'If this is art then I'm Leonardo da Vinci', to a piece that ran on 13 January 1994, two days after *House* was torn down by bulldozers, headlined 'Bringing the House down'. The Bow Councillor Eric Flounders pilloried the sculpture in a series of vitriolic letters to the *Independent* and elsewhere (which was rather ironic, since he was responsible for securing the licence for *House* in the first place). This provoked a counter attack by campaigners, who presented petitions and proposals to save the sculpture.

On 23 November, the same day that Bow Council made the decision not to grant *House* a stay of execution, Whiteread won the Turner Prize. She used her acceptance speech to condemn the Council's edict. She was also awarded a £40,000 prize for 'worst' artist of the year, an event staged outside the Tate on the night of the Turner announcement by an attention-seeking group calling itself the K Foundation (comprising former members of the pop group KLF). Whiteread divided the £40,000 between a fund for young artists and Shelter, a charity for London's homeless.

In the end, the relentless campaigning on Whiteread's behalf paid off, and a month later Bow Council capitulated and granted an extension to the lease on the site occupied by *House* until 12 January 1994. A number of people – from museum directors to collectors to sponsors – had by this point offered to buy *House*, but Whiteread was adamant

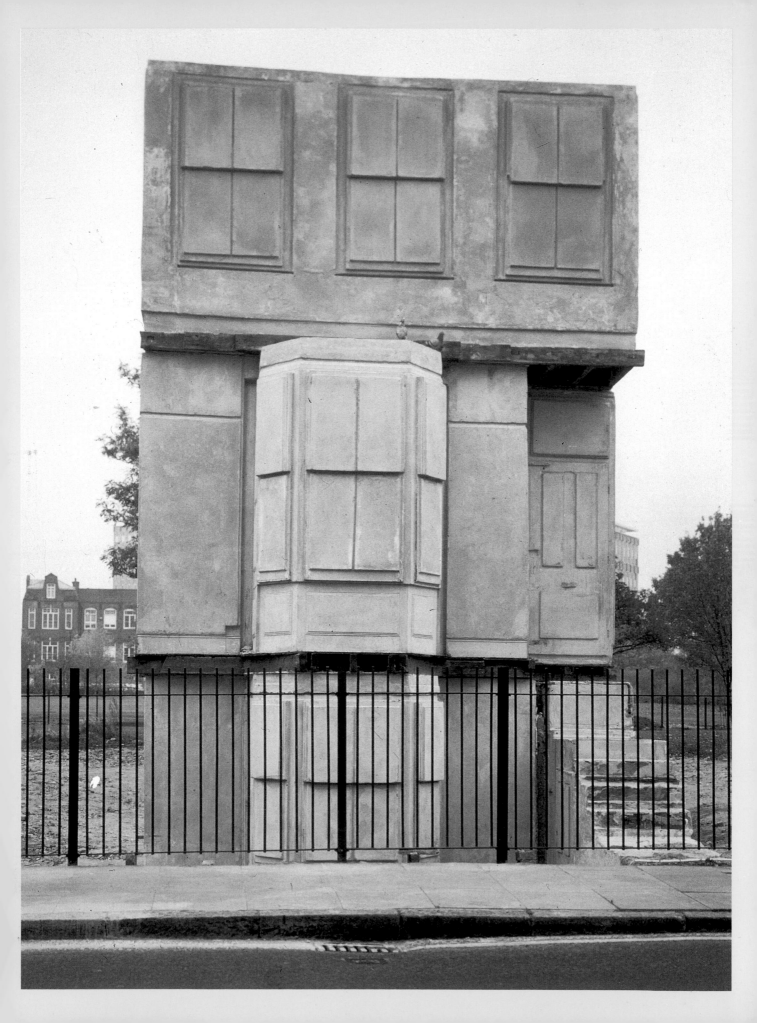

that it shouldn't be moved. While she had wanted the sculpture to remain in place long enough for it to become part of the fabric of the neighbourhood, she had always intended *House* to be a temporary structure.

By the time the bulldozers were ordered in on 11 January 1994, *House* had been seen by thousands of people from around the world, and discussed by thousands more. From the outset, Whiteread couldn't even stand in front of the sculpture for fear of being mobbed, and had to resign herself to looking at it from afar, sitting in her car at the end of the street and peering round a newspaper. *House* was a mute memorial for the area and its history, and a tomb that visualised the darker side of domestic life. But it also came to be a pawn in the political discourse, and was called variously a 'bunker', an 'eyesore', a 'mausoleum', and an 'exceptional work of art'. It was clever yet simple, a monument to thoughts and dreams and sensations, a human-sized foil to the faceless scale of Canary Wharf. And suddenly it was gone.

By the day of the demolition, it was covered in graffiti and beginning to look pretty sad; birds were living on it . It took three and a half years to develop, four months to make, and thirty minutes to demolish.

Now Grove Road is flanked by an unbroken stretch of flat green grass, and *House* exists only in photographs, drawings and the fragments that Whiteread collected from the ruins. But it also exists in the memories of all who saw or read about it – perhaps the most appropriate site for this silent monument to lost conversations and past lives.

UNTITLED (SIX SPACES) 1994 [39]
Resin, six parts
From 42 x 29 x 28.2 to 40 x 48.5 x 41.5
(16 1/2 x 11 3/8 x 11 1/8 to 15 3/4 19 1/8
x 16 3/8)
Arts Council Collection, Hayward
Gallery, London

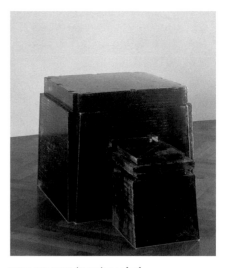

TABLE AND CHAIR (CLEAR) 1994 [40]
Resin
68.6 x 101.6 x 74.9 (27 x 40 x 29 ½)
Private Collection

ALCHEMY AT WORK

Whiteread had completed her DAAD Scholarship in the autumn of 1993, but the drawings she made in Berlin continued to tour after her DAAD Gallery show closed, first to Cologne and then to her New York gallery, Luhring Augustine. Simultaneously, a retrospective show of her sculpture opened at the Kunsthalle in Basel, and while it included works for which Whiteread was now internationally famous – *Closet, Ether, Untitled (Amber Bed), Untitled (Room)*, photographs of *House* – the show also included three new works from 1994, two in rubber and one in a medium new to Whiteread: resin.

Whiteread had always been fascinated by different materials: their individual properties, transformative abilities, colours and surfaces. She had employed organic products – wax and rubber, plaster from gypsum (a naturally forming calcium sulphate) – and explored their transitory capabilities, using them in liquefied states to submerge every surface detail in old furniture, and to bring it back to life once it had hardened. She had experimented with various types of each material, smearing thick black rubber onto hessian-coated beds, layering extra-fine dental plaster on mattresses to pick up the surface detail of fabric. Increasingly she sought help from engineers to push each material (and herself) further than it had ever gone before. Her use of resin continued this interest in transformative materials that have an innate instability. Starting out as a liquid, the solid resin hints at its original properties – in certain lights her resin sculptures seem to transform back into a liquid state. The manufactured resin favoured by Whiteread has parallels with the tree resin that captured prehistoric insects in its sticky ooze, killing them while preserving them, just as a wax death mask preserves a simulacrum of life while highlighting death. Again, death is as much a part of Whiteread's work as the

memorialising sense of immortality she captures, like three-dimensional photographs of time passed by.

When Whiteread started experimenting with synthetic resin, it was being used commercially to make nothing larger than paperweights. But wanting to cast the space beneath a table and chair, she embarked on eight months of laborious tests, trying to find a way of making the flammable and volatile polymer stable enough to use on such a scale. The result was *Table and Chair (Clear)* (fig.40), first exhibited at the Kunsthalle in Basel in 1994.

Whiteread has admitted that resin is a frightening material with which to work, but its unique properties make it worth the risk. Up until her first resin work, all of Whiteread's sculptures had been opaque, negotiated from the outside, the scale and surface the only ways in which to access each piece. Now Whiteread wanted to reveal the interior of each cast void, a more complex articulation of space that saw a simultaneous solidification and yet opening out of the spaces cast. She had tried to cast from coloured glass, which was similarly translucent when cast in thin sheets, but as a block, only resin would hold light inside itself, refracting it to appear as if it were illuminated from within.

Table and Chair (Clear) is the cast of the space under a squarish table and chair. Both objects were cast together, so that the chair form neatly slots into its own space in the cast from under the table. The chair cast is thus a removable block, a cast of a void, that leaves a new void in the larger cast of a void. This intricate play on space is further enriched by the glowing solidity afforded by the resin cast. The gently sloping sides of the main form are evenly cut into at the corners where the legs once were, a frieze-like cornice articulating the top of the sculpture where the wooden table-top support had sat.

UNTITLED (SLAB) 1994 [41]
Rubber
20 X 76 X 200
(7 7/8 X 29 7/8 X 78 3/4)
Private Collection

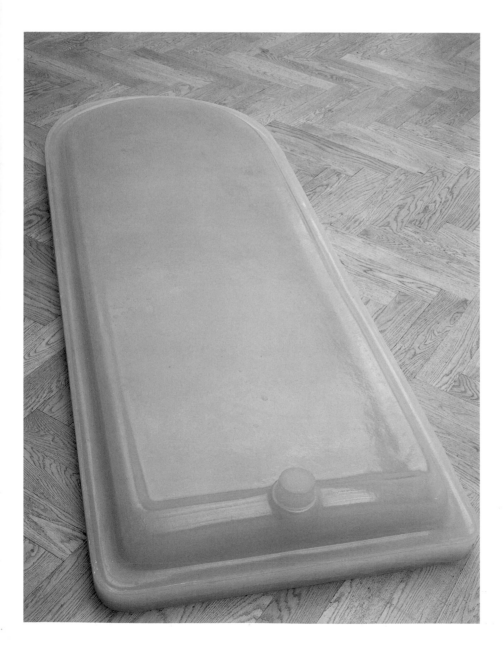

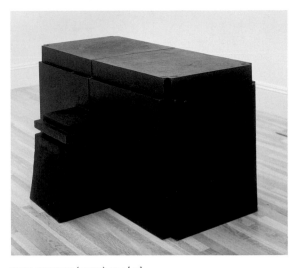

The sculpture takes on the appearance of an ancient temple, a solid windowless Mayan mausoleum or an Egyptian tomb. When the chair is pulled out from under the table it reveals an architectonic replica of its shape, burrowed into the table cast. Like a cavernous entrance hall, this shape seems to be guarded by its solid twin as if it were protecting a gateway to the spirit world. The inner glow of the resin suggests that this is a monumental piece of architecture designed to protect the dead and allow them passage into the afterlife. The light trapped in the resin also implies that the sculpture has a life of its own, the colours within the blocks constantly changing in different lights, flashing green and yellow and white and gold. Despite its domestic scale (it is under a metre high), *Table and Chair (Clear)* transcends its previous everyday role and becomes part of the same ritualistic cluster as *Ether, Valley* and *Ghost*. But unlike these works, where life was notably absent, here its essence has been forced back into the sculpture and appears to linger in the resin.

Also in Whiteread's Basel show were two other new works, both cast in rubber. One of these was another table and chair in dark green. Whiteread only rarely colours the materials with which she works, preferring their pigmentation to be inherent or come from the process of making the piece – absorbed from the walls in *Ghost*, dictated by the catalyst in *Table and Chair (Clear)*. *Table and Chair (Green)* (fig.42) was no exception; the bottle-green rubber had been coloured at the manufacturing stage, before she purchased it. Now it appeared opaque and robust, the resulting sculpture appearing as if it were somehow cast from malachite-edged basalt, its architectonic form solid, unflinching and timeless.

The third new work shown was *Untitled (Slab)* (fig.41), a sculpture that offered less promise of an afterlife. Cast from a rich orange rubber, it was the imprint from the surface of a mortuary slab obtained by Whiteread three years earlier. When she initially cleaned the slab, and removed the plug, she found that it was full of hair, the remnants of many lives that were already over once they reached this destination. In the sculpture, the inside of the plug now protrudes upwards, a tiny, hopeless phallic gesture in the fleshy rubber form, whose scale is based on human dimensions, and which lies stretched out on the floor, inert and spent. Whiteread has commented that 'we begin to die as soon as we are born', a statement asserted by this work, which resembles a golden coffin, or the lid to an ancient sarcophagus, a reminder of our mortality.

After making *Table and Chair (Clear)*, Whiteread started to concentrate solely on chairs, casting several series of spaces from underneath wooden seats of the kind found in church halls and schools, old dining rooms and public institutions. *Untitled (Six Spaces)* (fig.39) was the most colourful work that Whiteread had made to date, each uniquely proportioned chair-space a different shade: indigo, slate, tea, lime, antique gold, rose. They were of a similar height, but as individual as human physiognomy, the top of the broad tea-coloured block curving into a smile, the narrow loftiness of the lime space giving it a certain grandeur like arched eyebrows. Lined up as if for an identity parade, the works drew in light from outside their forms, and thus started to dissolve from the bottom up like mirages on a desert plain, palpable memories of the past lingering in the present. Whiteread had succeeded in transforming the most mundane object from our universal daily existence, the seat, into an object of beauty and mystery.

Untitled (Six Spaces) was followed by the watery *Untitled (Twenty-Five Spaces)* (fig.43), where the fir

UNTITLED (TWENTY-FIVE SPACES)
1994 [43]
Cast resin (25 blocks)
Each 30 x 30 x 40
(11 3/4 x 11 3/4 x 15 3/4)
Queensland Art Gallery

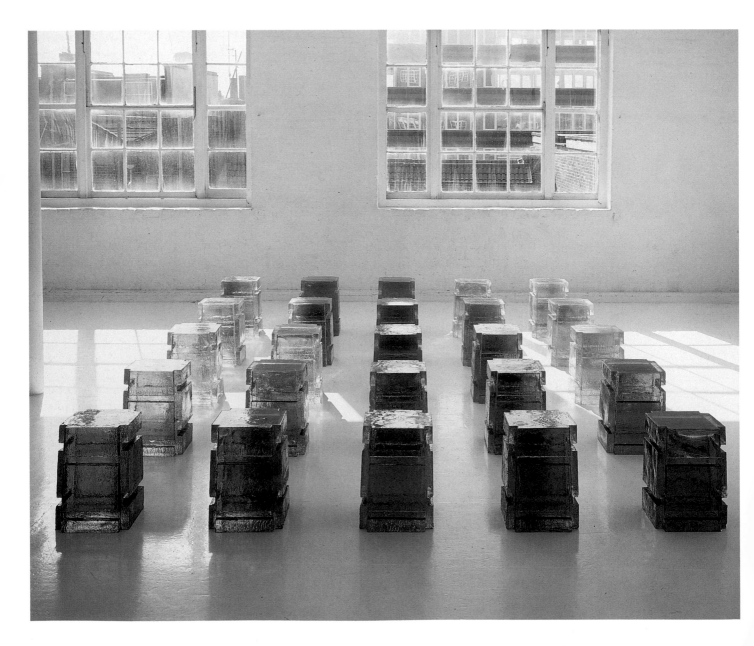

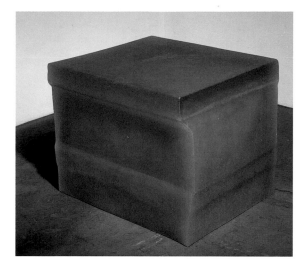

UNTITLED (RUBBER PLINTH) 1996 [44]
Rubber and polystyrene
68.5 x 76 x 86.5 (27 x 29 7/8 x 34)
Private Collection

green of an ancient iceberg's heart gave way to paler imitations so that the clearest blocks replicated the dancing light of surface water or melting ice. The largest series of 'spaces' was finished the following year (1995). One hundred spaces were lined up like miniature regimented troops across the gallery floor, the grid-like arrangement reminiscent of a military graveyard, the insubstantial multi-coloured forms like souls hovering at knee height as you passed among them (see p.70).

Whiteread made *Untitled (One Hundred Spaces)* in her studio in Carpenter's Road, Hackney. Formerly a Yardley's scent factory, it was filled with light. It was this element that was responsible for giving life to these squat forms. Through the casting process that Whiteread so carefully controlled to differ the colouration, she replicated the belief of second-century alchemists, extolled by Plutarch, that colour should not be an incidental quality in objects, but an integral part of their nature, an essence emitted by a central power.

Also in 1995, Whiteread made *Untitled (Floor)* (fig.45), a dark-green resin cast that forges further alchemical links. Cast in a similar way to the floor made for Documenta IX in 1992, it comprised seven rows of the spaces from between the joists of a 13-foot-square floor. In a shaded gallery space it was brooding, dark and secretive, but as soon as sunlight crossed it, it was transformed, the interior lighting up like a bevelled emerald, flashes of gold and copper glistening on the surfaces that had previously rubbed up against the joists. The uneven surface imprint of the rough-grained floorboards danced, and the previously dark spaces were exchanged for the translucency of a shallow lake.

The raison d'être of alchemists was to attempt to transform base materials, the *materia prima*, into gold. For them, this was an eternal material, the highest planetary metal and therefore symbolised by the sun, the life-giver. Gold meant life, and thus represented a transformation of inanimate into animate material. In this way alchemy replicated Pygmalion's desire to see his sculpture become flesh. The same desire has inspired Gothic writers like Edgar Allan Poe and horror-film directors such as Wes Craven and others, who breathed life into dolls or blurred the boundaries between reality and dream. Whiteread has an innate ability to work within this transitional space where the inanimate comes to life, where materials are transformed and gold results from casts of *materia prima*.

In 1996, Whiteread returned to casting from mortuary slabs. But unlike *Untitled (Slab)* of 1994 or *Untitled (Clear Slab)* of 1992, the source material for these sculptures was not apparent in the final form. She used two ceramic mortuary slabs to create a complicated mould from which she cast rubber plinths. Created five years before her clear resin *doppelgänger* of the empty plinth in Trafalgar Square was unveiled, these works were not based on existing structures. The size and height of the rubber plinths replicated that of the ceramic mortuary slabs, but the scalloped sides were designed by Whiteread, who fabricated a plinth in plaster, took a rubber and fibreglass mould of it and used it to cast the final rubber sculptures. Whiteread created a series of plinths, including *Untitled (Rubber Plinth)* and *Untitled (Rubber Double Plinth)* (figs.44, 46). The rubber is pale yellow, the colour of flesh with the blood drained away. And yet a plinth is traditionally associated with longevity and immortality. It is an architectural dais that raises the subject placed upon it beyond mortality to look down on the ephemerality of life from a position of permanence. But the subjects who

UNTITLED (FLOOR) 1994–5 [45]
Polyester resin
20.4 x 274.5 x 393 (8 x 108 x 155)
Tate. Purchased 1996

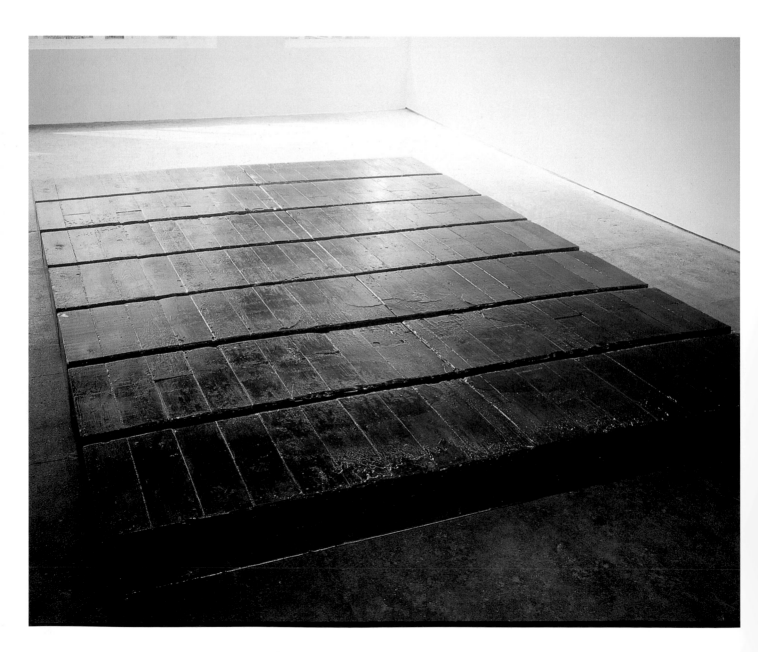

UNTITLED (FLOOR) 1994–5 [45]
Polyester resin
20.4 x 274.5 x 393 (8 x 108 x 155)
Tate. Purchased 1996

UNTITLED (RUBBER DOUBLE PLINTH) 1996 [46]
Rubber and polystyrene
Two units, each 68.5 x 76 x 86.5 (27 x 29 ⁷/₈ x 34)
Private Collection

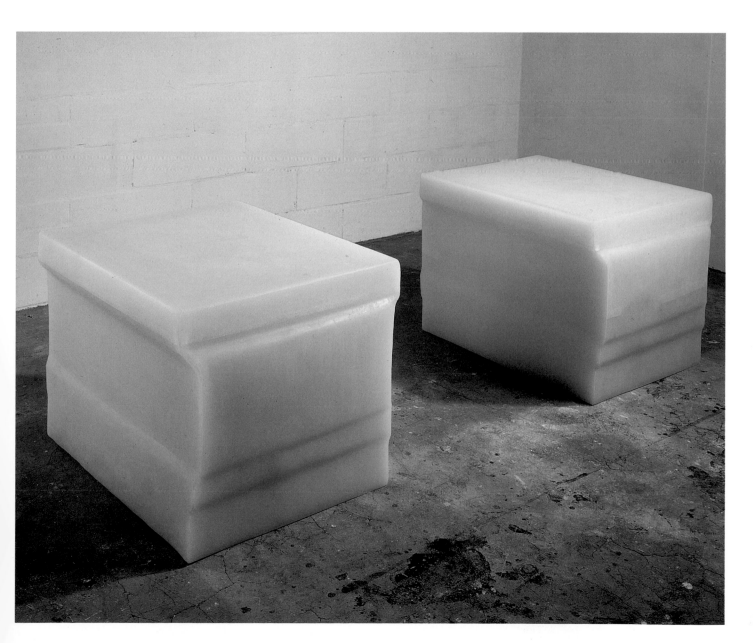

UNTITLED (BLACK BATH) 1996 [47]
Pigmented urethane and urethane
filler
80 X 207 X 100
(31 ½ X 81 ½ X 39 ⅜)
Private Collection

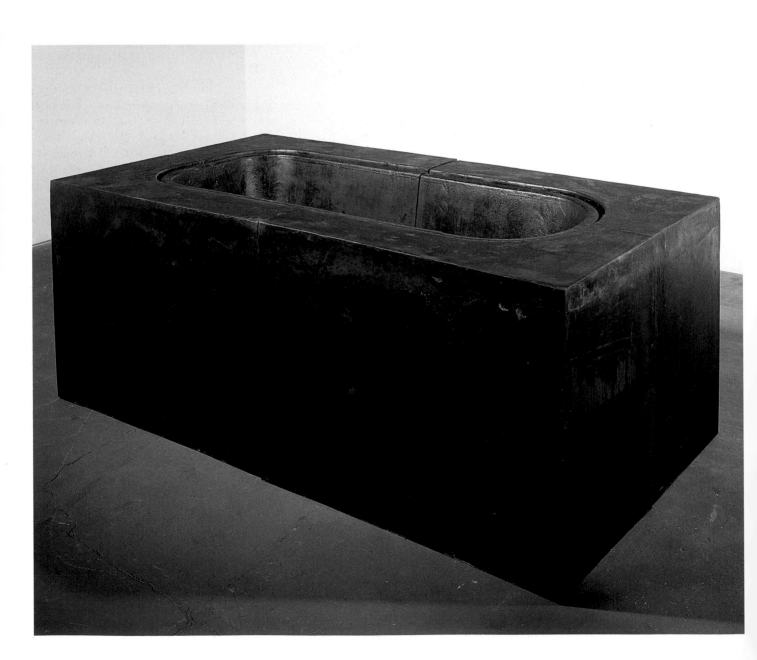

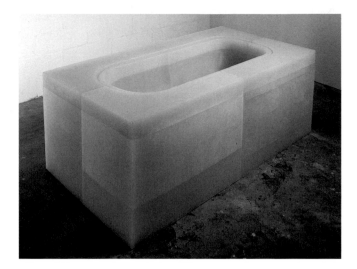

UNTITLED (YELLOW BATH) 1996 [48]
Rubber and polystyrene
80 x 207 x 110
(31 ½ x 81 ½ x 43 ½)
Private Collection

informed the scale of these pieces were cadavers.

In 1996, Whiteread chose to return to another object with which she had previously worked, also connected to death. This time using three different coloured rubbers, she cast a trio of sculptures from one bathtub, using a larger surrounding mould than before, elevating the bath's imprint. This time there was no sense of a person just departed, no trace of a particular body putrefied and present in the form of stains at the bottom of the tub. In these three new baths Whiteread had created timeless sarcophagi, the rubber clean-edged as freshly cut stone, the surface pristine and unchipped.

Untitled (Black Bath) (fig.47) looks as if it was hewn from a coal face in four blocks, traces of pale minerals seeming to run down each sheer face. As with the grandest Egyptian sarcophagi, it is hard to peer to the bottom of these human-scaled tombs, such is their scale and bulk. It is as if they have come directly from the landscape, as ancient as the earth itself, cut from age-old rock and stone. *Untitled (Orange Bath)* has below-the-surface flares of colour, as if cut from the same block of alabaster that Jacob Epstein used for his monumental *Jacob and the Angel* 1940. *Untitled (Yellow Bath)* (fig.48) seems to have been made from costly honeyed marble. And although each sculpture has a polystyrene core implanted in its centre to reduce its weight, they appear immeasurably heavy, solid and timeless.

In September 1996, Whiteread held her first major solo show in a public gallery in Britain, at Tate Liverpool. Called *Shedding Life*, it was a retrospective that began with *Closet* and ended with new work such as *Untitled (Orange Bath)* and *Untitled (Rubber Double Plinth)* (fig.46), which showed a renewed interest in physical death and destruction. *Demolished* 1996, included in *Shedding Life*, was a series of twelve

screenprints of three suites of photographs that Whiteread had taken around the time that *House* was completed. In each suite, four time-lapse photographs captured the moment when a high-rise block of flats was blown up, leaving a mushroom cloud of dust and smoke where people's homes once were (fig.49). Whiteread had wanted to record this dramatic detonation of post-war housing in London's East End, and as with *House* her work was the only remaining evidence that lives had once been lived on each site. The photographs were documents of loss, but they also captured the momentary transformation of all that was solid being turned into dust-clogged air, great cauliflowers of debris temporarily mimicking the cumulus clouds above them before collapsing back down to earth, leaving a fog like a pea-souper that brought back more distant memories of London's industrial past.

Shedding Life contained fifteen major works, as well as photographs and a film of *House*, and an additional seven sculptures were added when the show toured to Madrid in 1997. It was a significant reflection on her career to date, a chance for her to see work made over nine years that was now in public and private collections around the world. But one work that was included, a model of Whiteread's competition-winning entry to design a Holocaust memorial for Vienna that was due for completion later the same year, pointed to a fraught and challenging time ahead.

Whiteread won the competition to design a Holocaust memorial for Vienna's Judenplatz in January 1996, beating an international line-up that included Russian artist Ilya Kabakov and the Israeli sculptor Zvi Hecker. Although Whiteread had been invited to take part in the competition, she almost changed her mind about submitting her proposal – she wasn't Jewish, and had no familial connection

From DEMOLISHED 1996 [49]
Screenprint on paper
49 x 74.3 (19 ¼ x 29 ¼)
Tate. Purchased 1996

with the Holocaust. But, drawing on her time spent on the DAAD Scholarship in Berlin, her visits to concentration camps, and the overwhelming sense of history being quietly swept under the carpet that she had experienced when she lived there, she felt driven to participate.

Her winning model took the form of a concrete, windowless library, a pair of panelled double doors providing the only break in the book-lined walls (fig.50). However, the books that filled the shelves were turned inwards, their spines against the walls, with only the edges of their pages exposed to view. 65,000 Austrian Jews died as a result of the Holocaust, and in this library, filled with nameless volumes, the Jewish people – the People of the Book – were remembered. Like Jorge Luis Borges's Library of Babel, which is infinite and whose volumes are nameless, this fictional library can only be accessed through the mind. It can be both personal and collective, the lack of titles allowing access to anyone – any individual life could be on the spine of any given book. It is a memorial to lives lost, designed sympathetically while retaining a brutal rigour befitting a memorial to unspeakable loss. But, while it was initially scheduled to be unveiled in the square in the autumn of 1996, it would take another four years of battling to have the work cast and put in place, due to the volatile politics of Austria and the scalding debate triggered by the proposed Memorial (see p.88).

MODEL FOR JUDENPLATZ
HOLOCAUST MEMORIAL 1995 [50]
Mixed media
Height approx 30 (11 3/4)
Private Collection

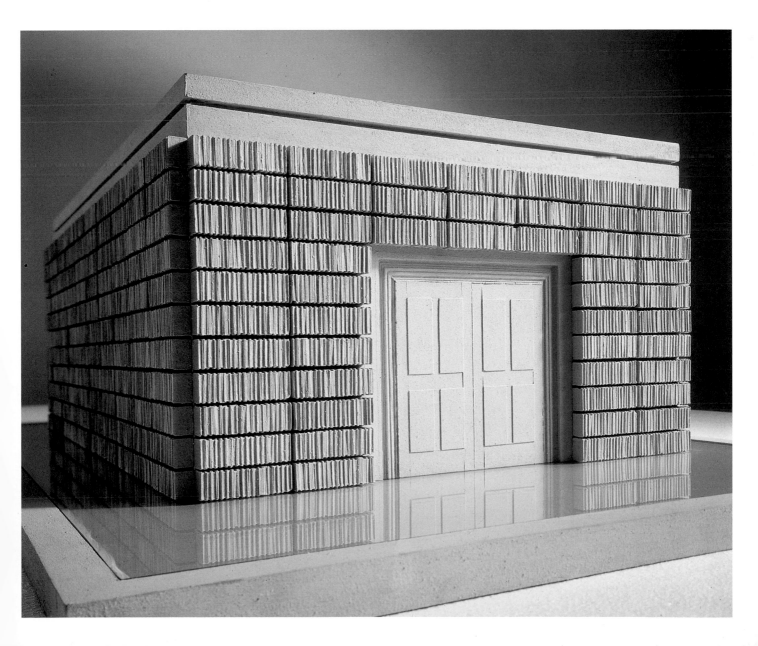

In 1995 Whiteread was invited to participate in the Carnegie International, a major triennial exhibition of international art held at the Carnegie Institute in Pittsburgh. One of the works she made for the show was *Untitled (One Hundred Spaces)*, a resin piece that comprised 100 casts of spaces from underneath the seats of old wooden chairs.

Whiteread had been using resin to create work since 1994. She had enlisted the help of a former chemist from South Africa, who was also a mould maker, but her early experiments with the medium didn't always go according to plan.

The first piece I made, I set the mould up to cast the table and chair, and I poured in the first layers. When I came back to the studio the next morning the whole thing had just exploded – fractured like a rock under very high pressure. The heat was extraordinary. I was very lucky not to have caused a fire.

A lot of the work I do involves pushing materials to the limit. With the resin pieces, the people I spoke to about the material, the chemists, were saying that the scale of what I wanted to do was impossible. The materials were designed for making paperweights, very small objects. I spent a lot of time figuring out how I could push it. Playing with materials is very much a part of my ongoing investigation.

After rigorous research into the limits of certain types of resin and catalysts, Whiteread and her team found a way to cast resin on a scale that had never before been attempted. The furniture was cast in plaster and then a mould was taken, and the pieces were finally cast from silicone rubber and fibreglass moulds. Resin was poured in at the excruciatingly slow pace of 2.5cm a day. This enabled the material to remain stable instead of overheating and exploding, and – as Whiteread became more experienced with using resin – the slow process enabled her to work at minimising the pour lines that can be seen in *Table and Chair (Clear)*.

The result in *Untitled (One Hundred Spaces)* is a series of multicoloured jewel-like blocks that threaten to dissolve in front of your eyes. By using resin, Whiteread yet again confounded visual expectations. The blocks appear insubstantial, composed of coloured light or at most a form of jelly that has been cajoled into occupying a rough cuboid form for just a few moments. Each block is a different colour, from the milky blue of Venetian canals to the bottle green of dense forests. Some are cloudy like jellyfish, others sparkle as if sunlight is lighting on the crests of tiny waves; all of them change colour in different lights and from different angles. They are as individual as people, some squat and broad and dark, others taller and paler. The chair may have gone, but it has left behind these iridescent spaces as if they are the memories of the people who once sat above them.

UNTITLED (ONE HUNDRED
SPACES) 1995 [51]
Installation view, Carnegie
Museum of Art, Pittsburgh
Resin, 100 units
Dimensions variable
Private Collection

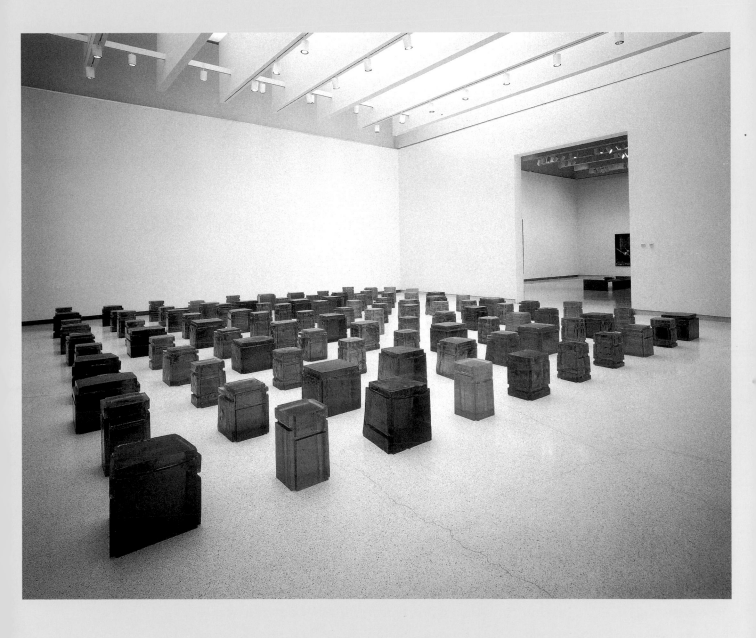

Untitled (One Hundred Spaces) *is probably the most colourful sculpture I ever made. It was a series of 100 chair spaces, nine different chairs, three different types of resin and three different types of catalyst. By mixing and changing the catalyst I could change the colour without using any pigment. It was a very complicated thing to do. It is about a kind of purity, I suppose, in material. I know the colour's there and I can work with it.*

Because the resin maintains its translucency even when cast on such a scale, the actual volume of each cast remains visible. With Whiteread's plaster casts, the back of each sculpture could only be viewed by circumnavigating the work, and the internal volume could never be seen. It was all about the surface, the interface between the object and the material.

There is a difference in the way the resin pieces are made. They're built up slowly. The resin blocks are very thick. When looking at the pieces one experiences a strange sense of being visually drawn into the dense matter, whereas the plaster pieces are very much to do with the surface.

In *Untitled (One Hundred Spaces)*, while these surface anomalies are still present – the recessed bars between the legs wonky and chipped, the seat of the chair not quite level – they are no longer visually dominant, and the eye is drawn into the material, moving around inside the resin as if feeling the space from the inside, the back and side faces of the form visible simultaneously.

Although Whiteread is the first artist to have used resin to cast the space underneath the seat of a chair, she is not the first to have cast this space. In the 1960s, while still a student, Bruce Nauman created a small series of works that investigated hidden space. He cast the space under a chair, the space under his hand as he wrote his name, the space between two boxes on the floor. His work was intentionally anti-Minimalist (the dominant art form of the day) and provocative. It shunned the Minimalists' industrial materials and the rigorous grid that informed their work; it dealt with the body and its messy and moveable place in the world. While Nauman quickly moved on from this line of casting, his *A Cast of the Space Under My Chair* (1965–8) has often been discussed in relation to Whiteread's work. And Whiteread did see Nauman's chair piece when she herself was a student.

I'd actually forgotten that I'd seen the piece by Nauman at a show that Nick Serota curated for the Whitechapel Art Gallery in London many years before. I just hadn't really noticed Nauman's piece at the time. I think I used the space under chairs for all sorts of other reasons. For me, it was a step to making an absent place for one person – or in the case of One Hundred Spaces, *an audience of people.*

Nevertheless, when she was asked to participate in the Carnegie International, she felt the need to deal with the persistent reported link between her work and his. By casting the chair spaces in resin, not plaster, Whiteread distanced herself from direct comparisons with Nauman's cast, while still acknowledging the visual connection.

When I made Untitled (One Hundred Spaces) *it was actually about confronting Nauman. I had to do it, and when I was invited to be in the Carnegie it felt like the right place to do it. Ultimately, I think that my work is more physiological, and Nauman's more psychological, conceptual. My works are very much connected with the body and with the human touch. Whether it's my touch, or someone else's, or a whole family's touch, they're about a piece of furniture that has been used.*

UNTITLED (ONE HUNDRED
SPACES) 1995 [52]

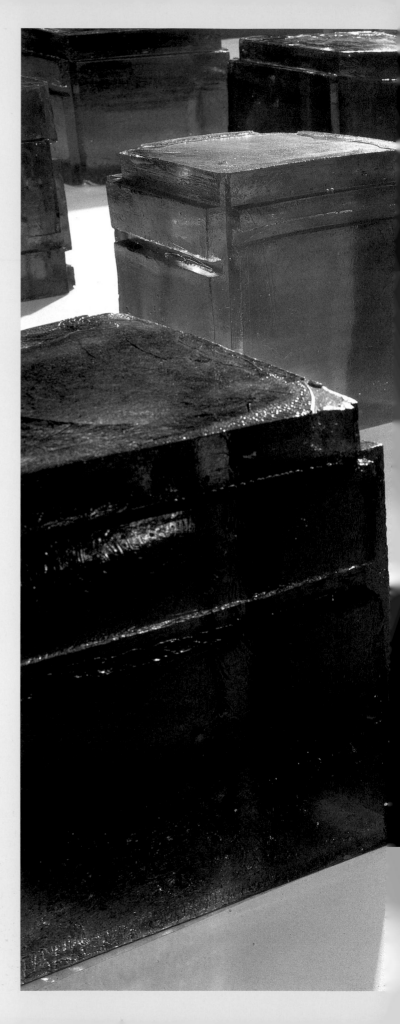

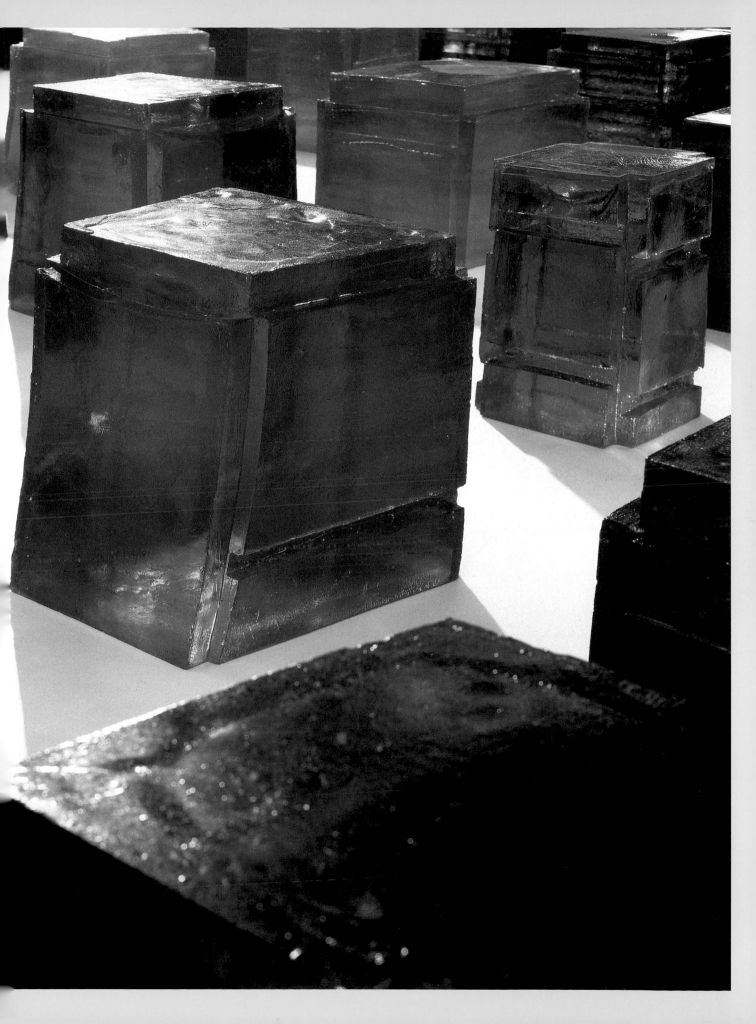

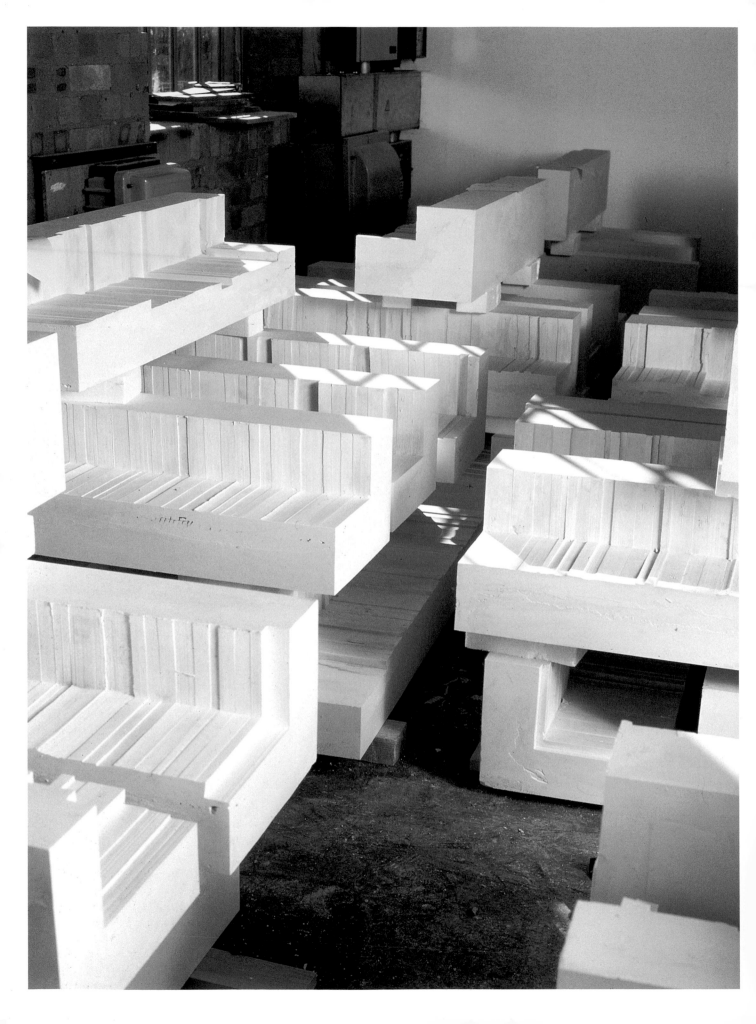

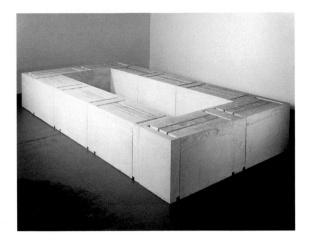

UNTITLED (PAPERBACKS) 1997 [53]
Installation in progress

UNTITLED (TEN TABLES) 1996 [54]
Plaster
72.5 × 293.5 × 478 (28 5/8 × 115 5/8 × 188 3/8)
Yale Center for British Art

PAPERBACK SCULPTOR

Whiteread's ongoing meetings with the Austrian government and Viennese local council regarding her proposed Holocaust memorial started her thinking about tables again. As she attended meeting after meeting in Vienna, held around endless board- and committee-room tables, she began to see new possibilities. Instead of choosing hand-me-down domestic furniture, she picked the standard table of the office and classroom, its symmetrical form designed to function on its own or grouped together. For Whiteread, the table was no longer specific, tied to home-spun memories, but utilitarian and ahistoric.

From these bland, bureaucratic tables Whiteread cast *Untitled (Ten Tables)* in 1996 (fig.54). The result was an almost-abstract interlinked puzzle. The casts of a geometric office table were arranged into a larger rectangular form, a central void penned in by nose-to-tail casts. These solid blocks were punctuated by diagonal holes where the legs once were, and by the shallow imprint of the horizontal struts that had held the table-top in place. The infinite circling pattern made by these reiterated forms had strong associations with the futile discussions that are often conducted over similar tables. Bureaucracy was revealed for what it often is – a stubborn blocking of new ideas, an endless round of repetitive and often pointless conversations.

Whiteread's work may have moved on technically and conceptually, as she dealt with increasingly complex moulds and transcended the early domestic connections made by her work, but in terms of materials she had returned to using plaster from which she cast her first postgraduate work. But now the plaster was no longer picking up scuffs and chips or fragments of paint. In *Untitled (Ten Tables)* the edges of the cast are crisp and sharp, the surface imprinted only with a fine nondescript grain. A faint sepia mottling that runs over the top of each cast alludes

to age, like the spotting found in old books or mould on walls.

Untitled (Ten Tables) is above all architectural in its form. Although just over seventy centimetres high, it has the monumentality of an Atlantic Wall bunker. With no side openings it appears windowless, turned in on itself, protecting the internal void. Even the indents on the top appear like archers' slits in castle walls, the minimum risk for maximum damage. Or the sculpture could be the excavated foundations of some vast fortress, solid, unbreachable, the spaces where the legs once were now mysterious holes for missing beams to take the building upwards. This isn't the small garrison of *Fort*, but a vast and faceless citadel, the centre of power.

Untitled (Ten Tables) was one of eight works that Whiteread chose to show in 1997, when she represented Britain at the world's longest-running and most prestigious international art Biennale in Venice, and where she was awarded the prize for best young artist. (She was also the first woman to have a solo show in the British Pavilion.) While *Untitled (Ten Tables)* occupied the central gallery, and referenced the endless battle to install the *Holocaust Memorial*, it was *Untitled (Paperbacks)* (figs.53,55) that visually connected with her proposed Viennese sculpture. As the *Holocaust Memorial* project was increasingly delayed, Whiteread began making other works that were based on books.

In the *Holocaust Memorial*, the books that line the walls are positive casts of wooden replicas, but in early test pieces Whiteread had experimented with casting from real books, ripping them out of the plaster to leave ripple-edged gaps. Whiteread's first sculpture made in this way was *Untitled (Three Shelves)* (fig.56), completed in 1995, when she was putting together her proposal for the competition.

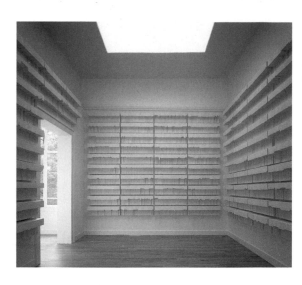

UNTITLED (PAPERBACKS) 1997 [55]
Installation at the Venice Biennale
Plaster and steel
Dimensions variable
The Museum of Modern Art, New York.
Gift of Agnes Gund and Committee on
Painting and Sculpture Funds

UNTITLED (THREE SHELVES) 1995 [56]
Plaster, three units
23 x 65 x 16 (9 x 25 5/8 x 6 1/4)
Private Collection

Books have always been a means of communication, a store of the history of the world passed down from generation to generation. Throughout time, when cities were conquered by invaders, libraries such as the Great Library at Alexandria were burnt down in a symbolic gesture that emphasised the fact that the past had gone and the future had arrived. The Nazis torched hundreds of thousands of books that disagreed with the way in which they believed society should operate. Destroy historic records, they reasoned, and you destroy history itself, an approach that Orwell parodied in *1984*, in which books are constantly amended in line with the dominant political party's ever-changing ideological agenda. Whiteread's sculptures connect with this loaded history of the book.

In *Untitled (Three Shelves)*, the books have disappeared. Carefully arranging second-hand paperbacks – sci-fis and James Bond novels, dog-eared and yellowing – on polystyrene shelves, she then covered them with plaster. When it had solidified, the shelves and books were physically torn out of the plaster. This very physical act of removal left traces of what once were pages scored into the surface, fragments of print embedded, the colour from the books seeping into the plaster.

While *Untitled (Three Shelves)* was relatively modest in scale, resembling a small set of bookshelves in a student's bedroom, *Untitled (Paperbacks)* was a full-scale home library. This work was installed in a windowless room in the British Pavilion, the entire wall-space lined with casts of shelves and books. It was hard to work out whether this work was positive or negative – you could see the irregular, recessed voids left by the removed books, yet the solid block representing the cast space above them seemed to be the shelf for the books on the tier above. It appeared as

if the books had gone, but a ghostly after-image was recreating the library for you one last time.

Looking at this installation, it became clear that thousands of books had been used to create the work, begging the question: where were they now? What had they been about? With the realisation that so many books had been destroyed to make the piece came a sharp sense of melancholy that so much knowledge had been irrevocably lost. Like the post-war wardrobe destroyed to make *Closet*, and the Victorian terraced home taken down brick by brick to create *House*, the books used to make *Untitled (Paperbacks)* no longer exist. And these particular volumes – cheap paperbacks that entertained a previous generation – will never be made again.

At the back of the British Pavilion, Whiteread installed a work from 1995. *Untitled (Resin Corridor)* comprises nine short resin blocks. These are the colour of a Venetian canal in shadow, blue-green and slightly cloudy, an internal milkiness that turns almost white when sunlight strikes it. Running in parallel with the canal behind the pavilion, they gave the impression that water had somehow been arrested mid-flow, hovering in the gallery space in a state of transmutation, not ice but water suspended in stasis.

Water has always held a certain fascination for Whiteread – she has cast sinks and baths, and determinedly experimented with resin to replicate a watery translucency. As a compound, water can exist in all three states – gas, liquid and solid – and this sense of imminent transformation is something that Whiteread has tried to recreate in many of her works by using unstable or changeable materials. It is not surprising, therefore, that when she was offered the chance to create a temporary public sculpture in New York, she chose to tackle this element head-on by casting a water tower. Whiteread had been offered the

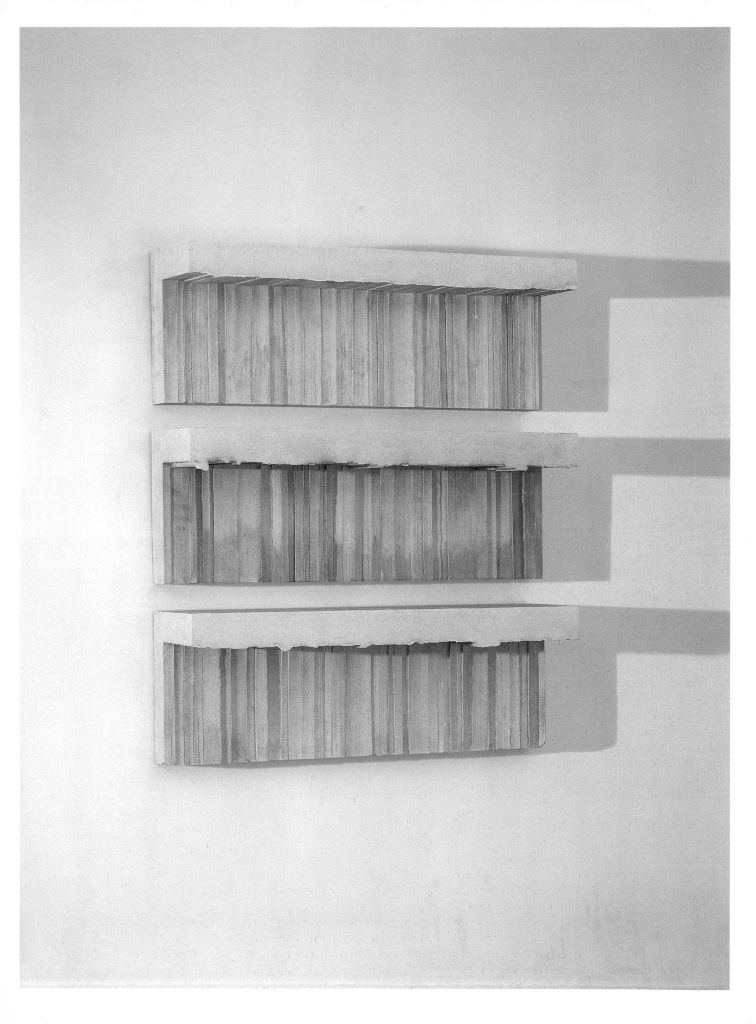

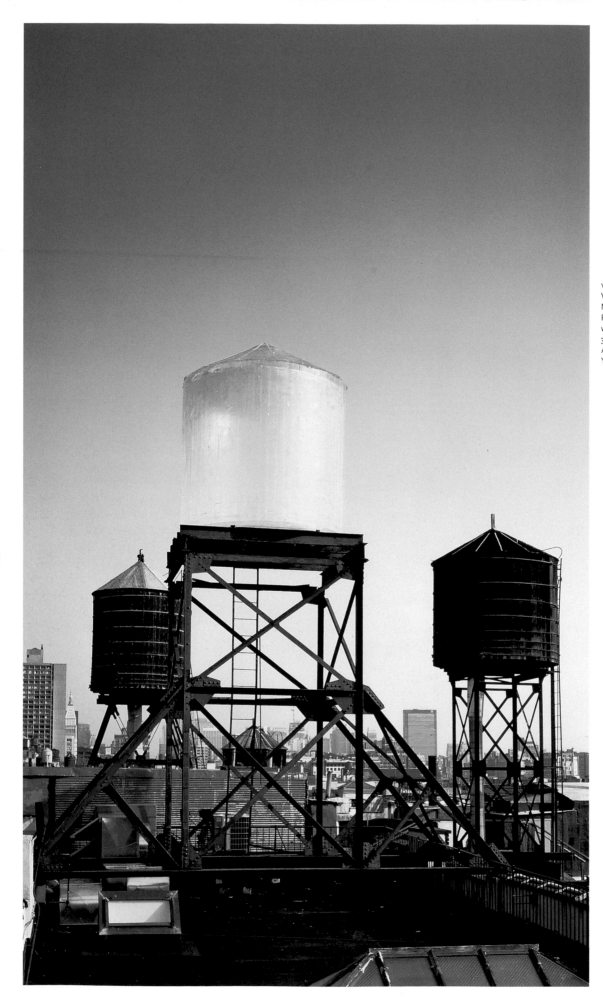

WATER TOWER 1998 [57]
West Broadway and Grand Street,
New York
Resin cast of the interior of a
wooden water tank
304.4 x 243.8 (134 x 96)
A project of Public Art Fund, New
York

opportunity to create a work in New York by the Public Art Fund just six months after she had completed *House*. She was very reluctant to take on another public commission, but she flew to New York to talk about it in the autumn of 1994, and used the opportunity to explore the city.

In 1973 Gordon Matta-Clark created a work called *Reality Properties*: *Fake Estates*, a series of photographs and inventories that documented the $25 lots of land he had bought at auction. These were the slivers of space left over between properties, inaccessible slices of New York. Similarly, when Whiteread first walked round New York looking for a site, it was the abandoned fragments of land between buildings that interested her most. But she soon realised that in a city as vertical as New York, she couldn't hope to compete with the architecture on street level. It took a trip to the Brooklyn side of Manhattan Bridge, which offered a skyline of Manhattan punctuated by thousands of cylindrical water towers, to work out what to do. She decided to cast the inside of a full-size water tower in clear, colourless resin, positioning it back on the metal frame that had supported the original wooden tank (figs.58–9). Placed in a semi-hidden location on top of a seven-storey brownstone in SoHo, it would be the antithesis of *House* by virtue of its barely-there appearance. It would engage with the skyline of New York and the other weathered water towers that stood nearby, accidentally discovered by passers-by.

Since the nineteenth century and until very recently, these external water towers were found on top of every building in Manhattan, and had remained virtually unchanged. They were integral to the daily events of life, providing the water for washing and drinking, cooking and cleaning. Like the Victorian terrace in London, they represented a piece of history

that still lived in the present, although it was one that was about to expire as New York's plumbing finally moved on.

But casting a wooden barrel that was 12-foot high and 9 foot in diameter was not an easy matter, particularly as nothing that big had ever been made in resin before. It took almost four years for Whiteread's idea to become reality, a time in which she had to find a suitable site, an available water tower, an engineer and insurer who would share her faith that such a cast could and should be made, and a type of resin that could rise to the challenge. When the water tower had been found, dismantled and dried out to ensure that no water was left in the wood (it would have reacted with the resin's catalyst and turned the cast cloudy), it was reassembled, and four-and-a-half tons of liquid resin were pumped in over twelve hours. Despite the fact that the mould cracked, and Whiteread and a team of volunteers had to spend three weeks chiselling the cast back into shape, it was finally lifted into place in June 1998, and remained there for two years.

As always, Whiteread kept tight control over how her work was seen. She refused to allow *Water Tower* to be lit, so that with the setting sun it became little more than a memory until the following day. She also refused to let it leave New York. A collector in Los Angeles was keen to buy it when it came down, but Whiteread was adamant – the water tower was indigenous to New York, and so the sculpture should remain there. (It was subsequently bought by the Museum of Modern Art.)

In *Water Tower*, Whiteread appeared to have solidified the water that once occupied the cedar tank, a solid block of translucent clear resin shimmering on a metal truss above a building as if it had suddenly been shorn of its container and still hovered in place. Under the hot summer sun it glowed like an apparition,

WATER TOWER 1997 [58]
Varnish, ink, collage on graph paper
149.9 X 213.4 (59 X 84)
The Museum of Modern Art, New
York

WATER TOWER 1997 [59]
Correction fluid, varnish, ink on
graph paper
149.9 x 213.4 (59 x 84)
The Museum of Modern Art, New
York

UNTITLED (DOUBLE) 1998 [60]
Plaster and polystyrene
72.1 X 228.9 X 65.1
(28 3/8 X 90 1/8 X 25 5/8)
Private Collection

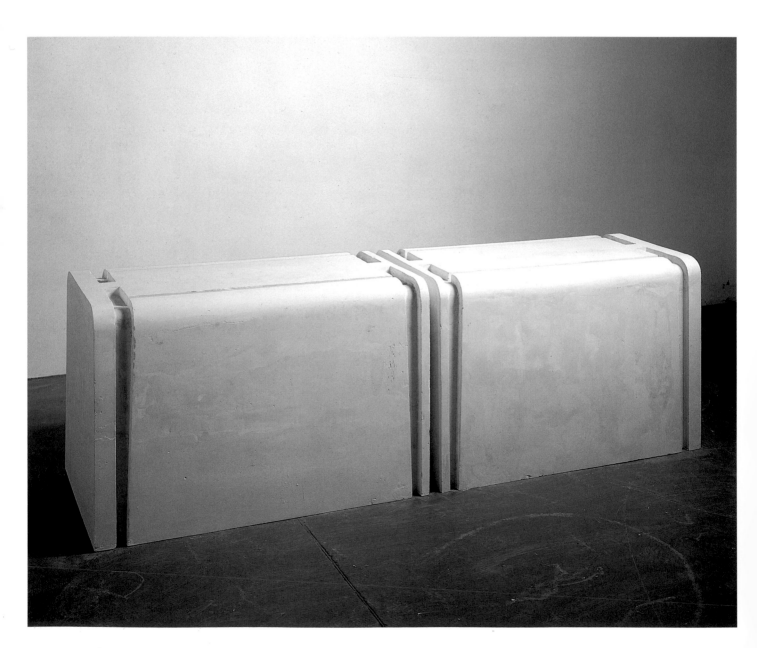

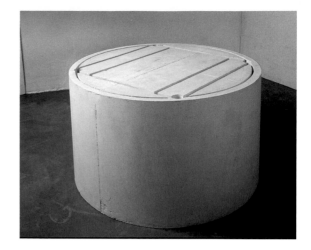

UNTITLED (ROUND TABLE) 1998 [61]
Plaster and polystyrene
70 × 120 × 120 (27 ½ × 47 ¼ × 47 ¼)
Private Collection

a blue-tinged impossibility against a clear sky. When the clouds rolled over, it all but disappeared, and at night it was cloaked in darkness.

In a book that accompanied the project, Whiteread included a range of photographs that she described as source material. Water, in all its guises, was the common theme – clouds, steam from city grates, crystallised patterns of snowflakes, rain, tornadoes, Niagara Falls and icebergs. She also showed how water can appear to bend objects through refraction, its transformative power not just restricted to its own properties but also changing those of things around it. Pictures of ectoplasm and spiritual happenings run alongside those of water, a further indication that the way in which the tower disappeared and reappeared was an integral part of the work. It was a ghost of its former self, inaccessible to the public (who could only view it from the ground) and liable to vanish from sight at any moment.

Eighteen months before *Water Tower* was installed, towards the end of 1996, Whiteread changed her London dealer. Previously she had been represented by Karsten Schubert, and her early commercial shows in London had been held at his first-floor gallery on Foley Street. But in October 1996 she moved to the Anthony d'Offay Gallery on Dering Street, and in October 1998 she held her first solo show there.

The largest work in the show was *Untitled (Book Corridors)* (fig.64). If *Untitled (Paperbacks)* had been a domestic library, *Untitled (Book Corridors)* represented a public one. Back-to-back shelves that reached above head height ran in narrow rows down the width of the gallery. The books had been ripped out to leave repeated patterns of white spaces like empty tombs, and there was an uncanny silence as you walked up and down the tightly packed rows. It was

quieter than a library, the plaster muffling footsteps. No books could be taken off the shelves to be read at home; no librarian was needed to date-stamp them. It was a *Marie Celeste* of a library, a relic in which all the pages had turned to dust and just the white skeleton of the spaces above and below them was left. Only the trace of a few page-edge indexes gave any indication as to the type of books they had once been. The millions of words that had formed the books from which she cast had been destroyed in the process of their removal from the plaster.

Other smaller book pieces were included in the show. *Untitled (Fiction)* (fig.63) comprised three empty shelf-like forms reminiscent of her first book piece. But unlike the bleached plaster of *Untitled (Three Shelves)*, *Untitled (Fiction)* is as colourful as a Paul Klee watercolour. Whiteread used the absorbent properties of wet plaster to suck the colour from cheap novels, whose edges were tinted canary yellow, cerise, turquoise. Like the 1950s stain paintings of American artist Morris Louis, the colour became part of the support, in this instance the plaster. Bands of colour lie in the plaster, resembling layers of sediment, each absorbed at different rates like a scientific chromatography test; yellow rises the furthest, while pink and blue barely leave the edges where the books once lay. As with all scientific tests, Whiteread had to work hard to ensure that the conditions were just right – if the books and plaster connected at the wrong time, the transference of colour would not take place.

Whiteread's solo show at the Anthony d'Offay Gallery was held as her *Holocaust Memorial* floundered on the table in Vienna. The frustration caused by the endless delays and hurdles placed before her was evident in her book pieces, which by the time the *Holocaust Memorial* was unveiled in 2000 had become increasingly violent in their manufacture.

UNTITLED (ELONGATED PLINTHS)
1998 [62]
Plastic and urethane foam (three
elements)
Overall dimensions: 67.3 x 376.6 x 221
(26 ½ x 148 ½ x 87)
Art Gallery of New South Wales,
Foundation Purchase 1999

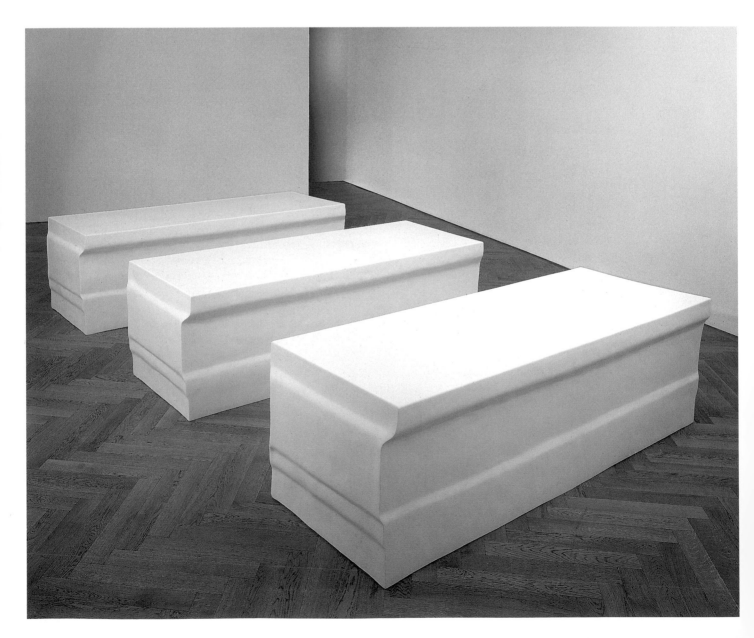

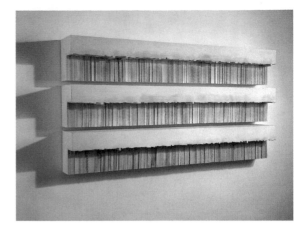

UNTITLED (FICTION) 1997 [63]
Plaster, polystyrene and steel
97.5 × 193.5 × 25.5 (38 3/8 × 72 1/4 × 10)
Private Collection

Whiteread had been asked to relocate her proposed *Holocaust Memorial* to another square out of the old Jewish quarter. But her sculpture had been conceived in response to the very specific site of the Judenplatz, and she refused. As Richard Serra had said before he lost the battle in 1989 to keep *Tilted Arc* (his most famous public sculpture) in place in the Federal Plaza in New York: 'to move the work is to destroy the work'. Whiteread held her ground, and the project finally progressed, one step closer to its inauguration.

During 1998 and 1999, Whiteread continued the investigation of plinths that she had started in 1996. *Untitled (Elongated Plinths)* 1998 (fig.62) was also shown at the Anthony d'Offay Gallery. Three pale plastic forms stretched along the ground, the length of bodies, like coffins sealed in wax, a site of death as well as immortality. The following year she made *Untitled (Pair)*, again using mortuary slabs to create the work; this time a simple concave slab created the smooth plaster top of one, reversed on the other to form a subtly convex shape.

In October 2000, Whiteread's *Holocaust Memorial*, her first permanent public sculpture, was finally unveiled in Vienna's Judenplatz. It had taken five years from winning the competition to its inauguration, and she had had to fight every step of the way. But while the finishing touches were being made to this memorial, Whiteread was suffering more frustration with regard to another public sculpture, *Monument*, a temporary work made for the empty fourth plinth in Trafalgar Square.

UNTITLED (BOOK CORRIDORS) 1998 [64]
Plaster, polystyrene, steel and wood
Overall dimensions: 222 X 427 X 523
(87 3/8 X 168 1/8 X 205 7/8)
Private Collection

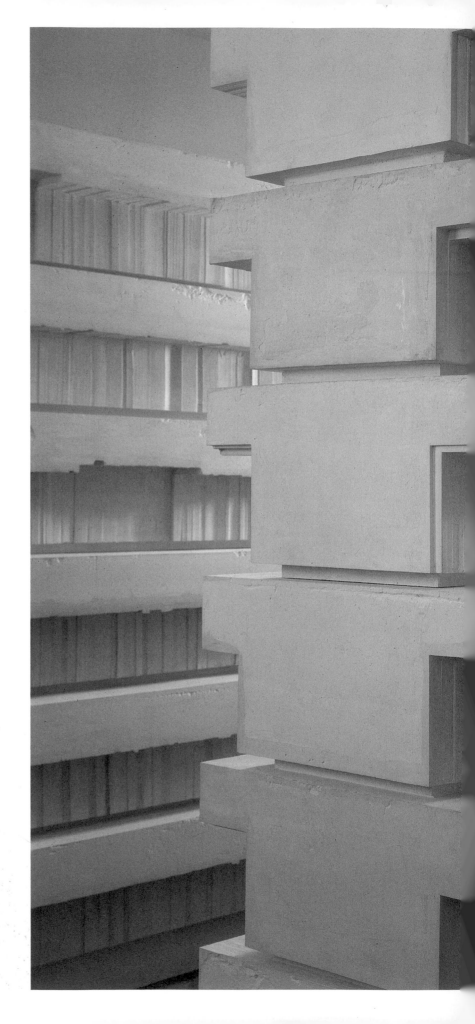

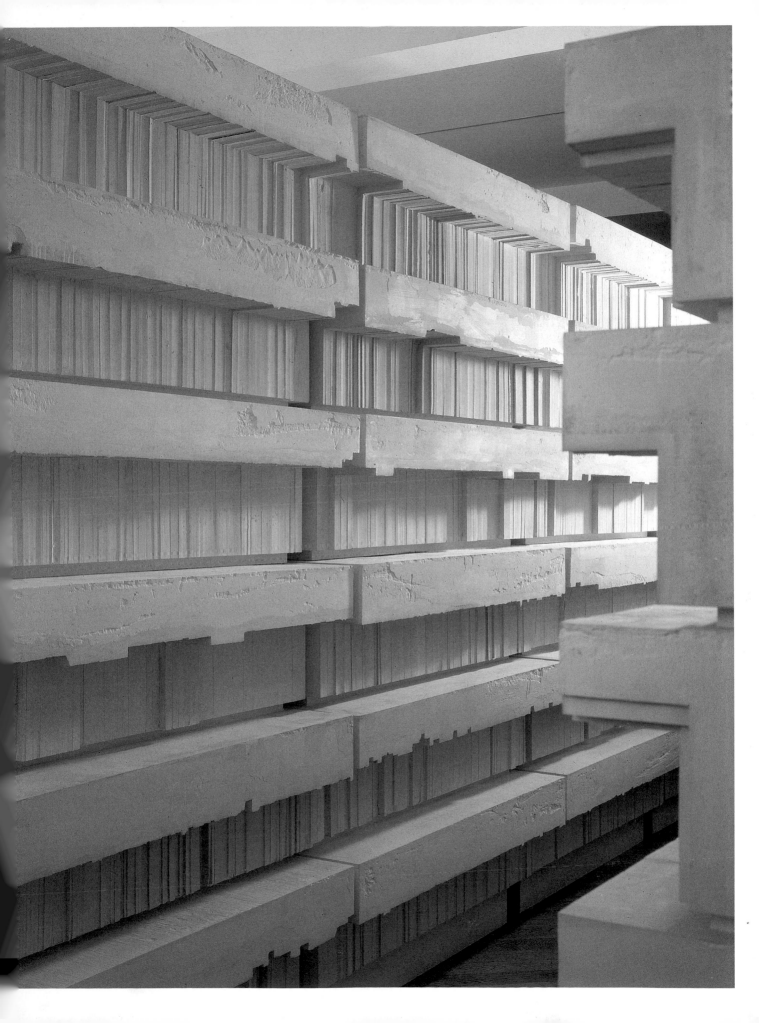

This extract is taken from an interview by Craig Houser, published in the catalogue for Whiteread's 2001 Guggenheim exhibition, *Transient Spaces*.

CRAIG HOUSER *In October 2000, after five years in the making, your* Holocaust Memorial *was finally unveiled in Vienna's Judenplatz, which is largely a residential square. For the project, you created a single room lined with rows and rows of books, all of it rendered in concrete. There is a set of closed double doors in front, and the names of the concentration camps where Austrian Jews died are listed on the platform surrounding the memorial. The piece is located near the Holocaust Museum in Misrachi Haus, and sits to one side of the Judenplatz, directly above the archaeological site of a medieval synagogue. How did you get involved in the project, and what was on your mind as you created the piece?*

RACHEL WHITEREAD When I came back from Berlin [after an eighteen-month DAAD scholarship there], I was asked to make a proposal for the Holocaust Memorial in Vienna. I had never been to Austria, and I looked at this project and thought, very innocently, that Vienna would be an equivalent to Berlin, and it would be an interesting place to try to make a memorial to such atrocities.

In Berlin, I did a lot of reading. I also went outside the city and visited some concentration camps and thought long and hard about what had happened and how people have dealt with the Holocaust. I was very interested in the psychology of that experience, and the repercussions of it within the city.

When I went to Vienna, I didn't realise that the politics would be so different from the politics in Berlin. And I didn't think for a moment that my proposal would actually be chosen.

CH *Why was that?*

RW There were twelve to fifteen international artists and architects who had been asked to submit proposals, and I was a baby compared to most of them. In the end, I was selected, which was a mixed blessing. It entailed five years of very, very difficult problems – with the city, the bureaucracy, and the politics. Luckily, I worked with some really great architects there; if it wasn't for them, I probably would have been crushed by the whole experience and might have just given up. I can't say I enjoyed

making the piece at all, though I'm very proud that it's there.

CH *In making the casts of books for the memorial, you did it differently from most of your other book pieces. Instead of doing negative casts – showing the space around the books – you created positive casts. The leaves of the books protrude toward the viewer, and we end up seeing what appears to be a library from the outside. What is the significance of these positive casts?*

RW When I was making this piece, I was thinking about how it might be vandalised, how it could be used without being destroyed, and how it should be able to live with some dignity in the city … I knew my piece was going to be a memorial, and I wasn't quite sure if it would be respected. So I made replaceable book pieces that are bolted from the inside, and a series of extra pieces to serve as replacements if necessary, in case there is some terrible graffiti.

CH *So the reason for creating positive casts was a means to overcome the threat of vandalism.*

RW They are also much easier to read as a series of books, and I didn't want to make some thing completely obscure. I mean, some people already think it's an abstract block that they can't really understand; others think it's an anonymous library. It also looks quite like a concrete bunker.

CH *The bunker is a means of protecting oneself. I see the piece as a metaphor for protection on many levels.*

RW I wanted to make the piece in such a way that all the leaves of the books were facing outward and the spines were facing inward, so that you would have no idea what the actual books were.

CH *Why did you want to hide the names and titles of the books?*

RW I don't think that looking at memorials should be easy. You know, it's about looking: it's about challenging; it's about thinking. Unless it does that, it doesn't work.

CH *The library you've created seems institutional. The books are all the same size, placed in neat, even rows, and they fill the walls side to side. They look systematised.*

RW The original books for the cast were made from wood, so they are completely systematised.

CH *So nothing was ever really 'documented'.*

RW No. There's nothing real about that piece at all, in a way. The doors were constructed; I constructed the ceiling rose. It's all about the idea of a place. Rather than an actual room, it's based on the idea of a room in one of the surrounding buildings. It was about standing in a domestic square amidst very grand buildings, and thinking about what the scale of a room might be in one of those buildings. I didn't ever want to try to cast an existing building.

CH *Other art and architectural projects related to the Holocaust were created at the same time as yours. Does your piece relate to Micha Ullman's Bibliothek, 1996, a memorial against Nazi book burnings in Berlin? Or Daniel Libeskind's Jewish Museum, 1997 in Berlin?*

RW No. In terms of other works, I actually think the memorial has far more in common with Maya Lin's Vietnam Veterans Memorial in Washington DC. When I was thinking about making the Holocaust Memorial, I spent a week there, and visited Lin's memorial twice. I wasn't interested in the politics related to the monument, but the way people who are alive today respond to it, reacting to something that may be within their history or within their own family's history. Lin's piece showed incredible sensitivity and maturity.
When I visited concentration camps, I was more interested in how people responded to the camps than in the actual places. I spent a lot of time just watching people. I watched kids picnicking on the ovens, and other people stricken with grief. I saw grandparents with their grandchildren, having the most appalling experiences, trying to somehow tell this younger generation about the past.

CH *So now that the memorial is completed, how has it been received?*

RW I'm very surprised. It's actually very moving how people have reacted to it. I had expected graffiti, but people have been leaving candles, stones and flowers on the memorial. I think it's already become a 'place of pilgrimage'. People come into the city and go to Judenplatz specifically to see the memorial, the museum in Misrachi Haus, and the excavations of the medieval synagogue underneath the square. If I've in any way touched people, or affected a certain political force in Austria, I'm very proud to have done that.

HOLOCAUST MEMORIAL
1995/2000 [65]
Judenplatz, Vienna
Mixed media
390 X 752 X 1058
(153 5/8 X 296 1/4 X 416 7/8)

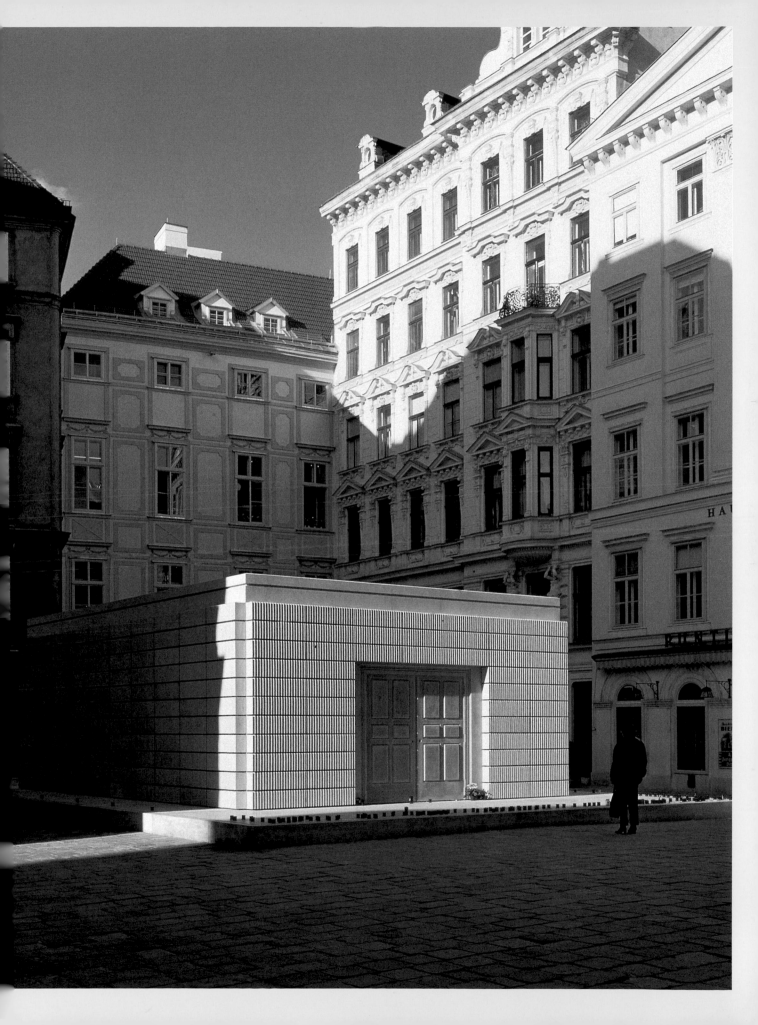

MONUMENT 2001 [66]
Trafalgar Square, London
Resin and granite
900 X 510 X 240
(354 5/8 X 200 7/8 X 94 1/2)
Private Collection

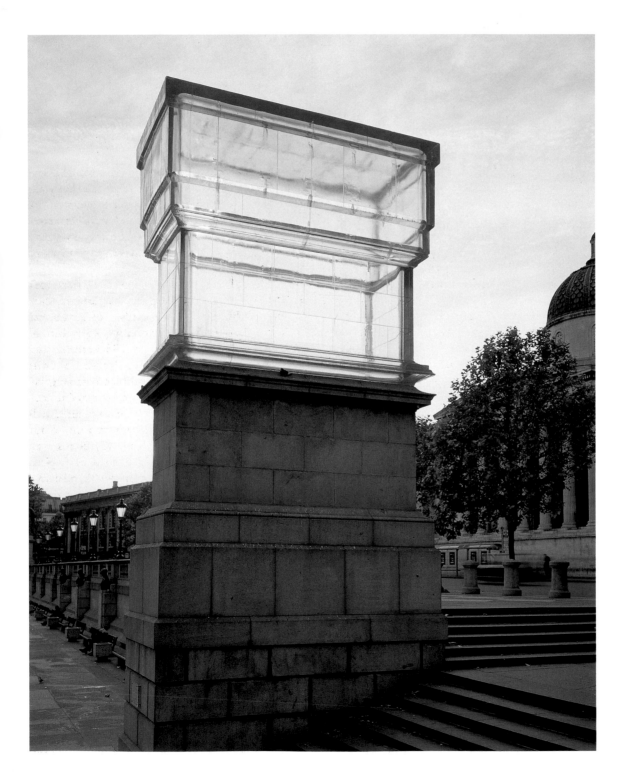

6

As Whiteread's *Holocaust Memorial* was finally unveiled, her series of bookshelves and libraries came to an end. Some of her pent-up frustration had been dissipated by the physical action required to tear the books from their plaster moulds. Towards the end of the series she had started using hardback books, as in *Untitled (2000)* (fig.68), that required even more brute strength to remove them, often leaving torn shards of covers and pages still embedded. There is something geological about these late shelf pieces. In *Untitled (Library)* (fig.67), 1999, the more rigid spines of the original hardback books have left a distinct outline written into the plaster, like the crumbling edge of a cliff-face or cave entrance. The plaster hangs in calligraphic stalactites, as if the words from the books have been transformed over time into script-like loops and whorls that now hang over the void left by the books themselves.

As Whiteread was bringing this series of sculptures to a close, she was working on a large resin cast for the fourth plinth in Trafalgar Square (fig.66). Though it was called *Monument*, the work was everything a monument was not – it was temporary, non-specific and near-transparent. It was a ghostly reflection of the plinth, a *doppelgänger* of the architecture that had been designed to showcase bronze statues of war heroes, not a replica of itself.

The fourth plinth series of temporary public sculptures was suggested by the Royal Society for the Encouragement of Arts, Manufactures and Commerce (RSA) to fill the plinth that had remained vacant throughout its 158-year existence. The other three plinths hold bronze statues of King George IV, General Charles Napier and General Henry Havelock, and all four were part of Charles Barry's design for the square in 1841. They are dwarfed by the vertiginous Nelson's Column, flanked by Edwin Landseer's popu-lar bronze lions. Whiteread was initially sceptical about putting a sculpture in the square, but after spending a day observing comings and goings in the area, she began to see the plinth as a formally interesting piece of architecture, a foil to the busy transitory nature of the square that at that time functioned as a glorified roundabout.

Whiteread's sculpture was the third and final work to appear on the plinth, and followed Mark Wallinger's life-size statue of Christ, *Ecce Homo*, and Bill Woodrow's large bronze tree, *Regardless of History*. After studying the pace of life in the square, Whiteread wanted to create a 'pause', a quiet moment. The empty plinth already had a certain gravitas of its own, so Whiteread used its muted monumentality to create her work, an eleven-and-a-half tonne cast of clear resin that replicated the plinth itself, aping its dimensions – 9 x 5.1 x 2.4 metres – but presenting it as a reflection of itself. It was as if a giant mirror had been placed on top of the plinth, reflective side down, and you stared up at a reversed copy of it, seemingly palpable but ultimately an illusion.

Since it is a listed monument (paradoxically, given that it has never been occupied), Whiteread was unable to cast directly from the plinth. She therefore had to build a replica and create a mould from this. It was the largest artificial resin cast ever made, and Whiteread used all her experience gained from casting *Water Tower* in 1998 not only to convince engineers and fabricators that the cast was possible, but to ensure that the sculpture didn't crack or shrink as it was created. The mould alone took four months to make, and with the research and development that went into casting the sculpture, it was delayed by almost a year. But in June 2001 it was unveiled, and remained on the plinth for five months.

Monument replicated the horizontal blocks of the

UNTITLED (LIBRARY) 1999 [67]
Plaster, polystyrene and steel
368 x 530.6 x 244.5 (145 x 209 x 96 ½)
Hirshhorn Museum and Sculpture
Garden, Smithsonian Institution,
Joseph H. Hirshhorn Purchase Fund,
2000

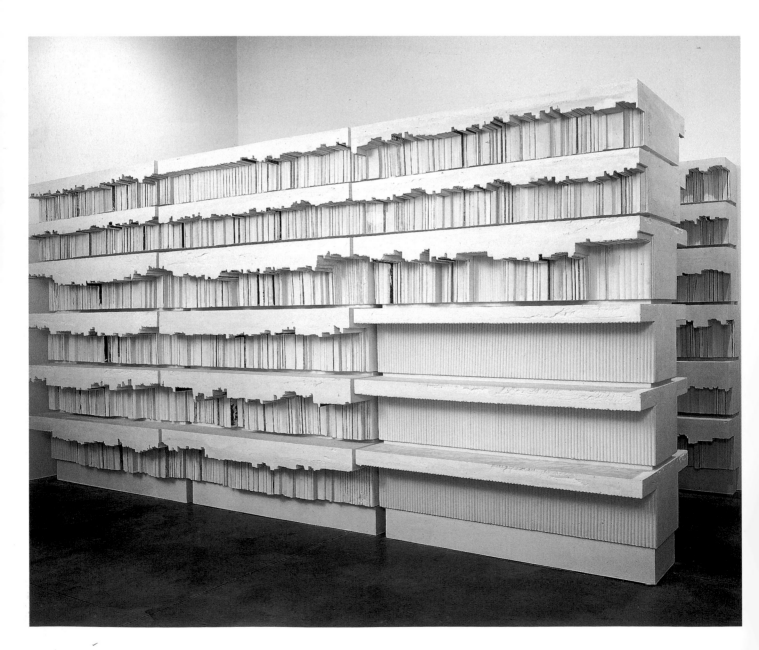

UNTITLED 2000 [68]
Plaster, polystyrene and steel
92 X 120 X 22 (36 1/4 X 47 1/4 X 8 5/8)
Private Collection

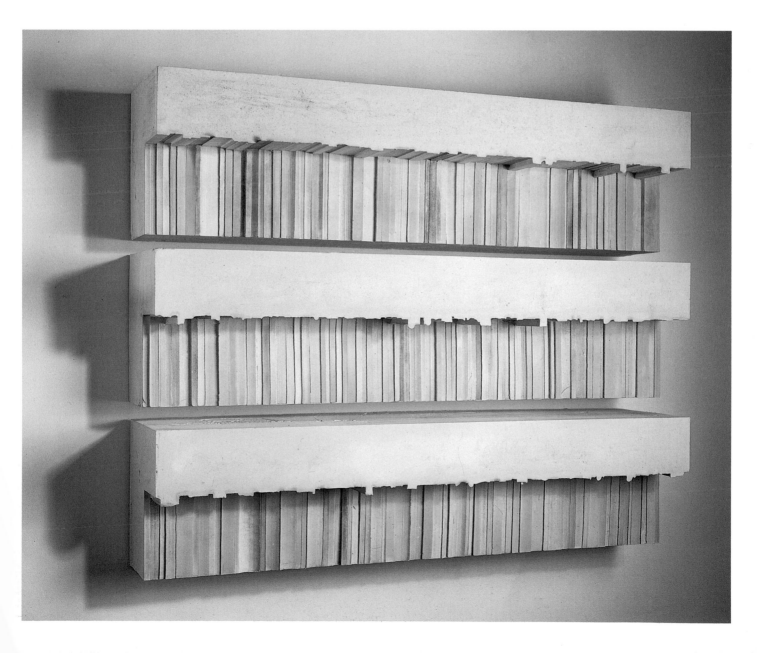

UNTITLED (CAST IRON FLOOR) 2001
[69]
Cast iron and black patina, 99 units
Overall dimensions: 1 x 502 x 411
(3/8 x 197 3/4 x 161 7/8)
Private Collection

original plinth, its indentations and cornice-like edges, yet it was transparent and seemingly light as opposed to solid stone, as if it were made of ice or air. It was a positive recreation of the plinth on which it stood (rather than a negative cast like the one she had made inside the water tower) but it had been inverted; instead of tapering towards the top, as the plinth did, it defied gravity, gently swelling as it rose away from its solid twin. In *Monument*, Whiteread has seemingly frozen the air above the original plinth and forced us to consider the two objects – the historic piece of the square's furniture alongside the translucent resin replica – as one. The fabric of the city could be seen through its sheer walls, while it seemed to dissolve in front of your eyes, as ephemeral as a dream. To make eleven-and-a-half tonnes of resin appear as a mere echo of something solid was a grand illusion. *Monument* spoke of our fascination with immortality, of the desire to live forever. It was a confluence of Ovid's Narcissus and Echo: our egotistical ambition to see ourselves immortalised on a pedestal alongside the generals, translated into a ghostly sculptural echo of ourself. Yet in its form it appeared coffin-like, a glass tomb akin to Lenin's, a mausoleum worthy of another Victorian construct of immortality, Highgate cemetery.

Two weeks after the sculpture was unveiled, Whiteread's first solo show in a public London gallery opened at the Serpentine. Unlike her exhibition at Tate Liverpool in 1996, she did not use this opportunity solely to look back on her career, but presented new work in two of the four main gallery spaces. At the entrance to the Serpentine Gallery, the smooth parquet had been partially covered with a series of slightly uneven, wobbly cast-iron squares, the dark surface marked out like floor tiles. Whiteread deliberately placed *Untitled (Cast Iron Floor)* 2001 (fig.69) in the entrance to the first gallery, hoping that visitors would walk on it before they realised it was there. She had been investigating the space beneath our feet throughout the 1990s, in her series of casts of the spaces under and over floorboards. But since 1999 she had been casting floors in bronze and iron, creating metal prints of the inverted surfaces of tiled rooms and wooden floors, such as *Untitled (Cast Corridor)* 2000 (fig.71). The first work in this vein was *Untitled (Bronze Floor)* 1999–2000, supposedly made for the Haus der Kunst in Munich to inaugurate its new building. Whiteread took a print of the old gallery's floor, and relocated it to the new one, transferring seventy years' worth of marks and scratches in the original stone floor to the pristine new space. The bronze surface was treated with a wax-based patina, and the public was invited to walk across it. As in *Untitled (Cast Iron Floor)*, this surface subsequently rubs off over time to reveal the tiny protrusions that have been created by negative casting. Where hammers were dropped from ladders, or furniture scored grooves in the floor, the reversed-out indents stood proud of the overall surface.

Initially, Whiteread's metal floors seem to have much in common with Carl Andre's series of floor pieces from the 1960s. But while his smooth tessellations of bronze and copper speak physically about form and weight and the charged air above them, Whiteread's floors are imprinted with past life. With each footstep that falls on them they continue to develop, a little more of the specific history of each floor shining through, buffed to a sheen like the hands and faces of religious statues touched a thousand times.

Whiteread's other major new work in the Serpentine exhibition filled the central atrium. It was a cast of a staircase, *Untitled (Upstairs)* (see p.110).

UNTITLED (CAST CORRIDOR) 2000
[71]
Cast iron (24 units)
Overall dimensions: 1.5 x 226 x 405
(3/4 x 89 x 159 1/2)
Private Collection

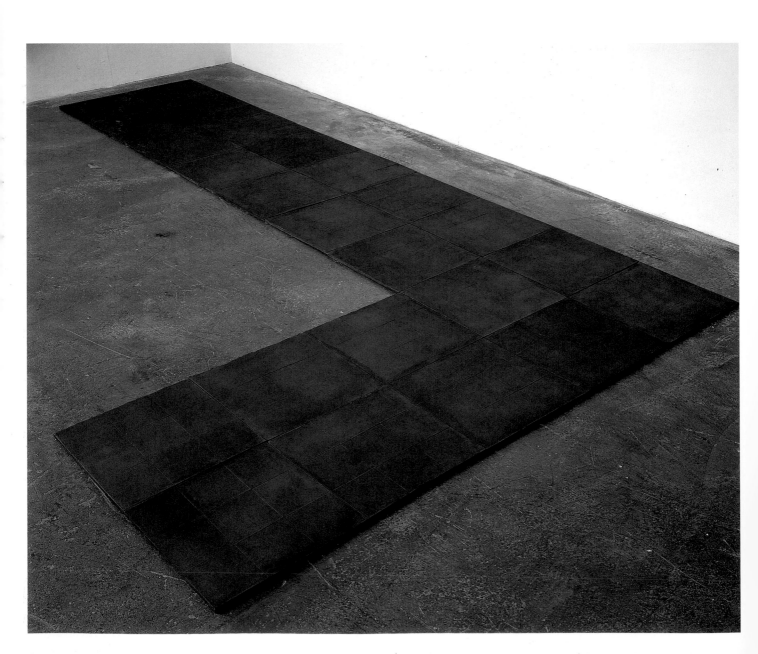

Like corridors, staircases are places of transit, non-places where you rarely pause. But Whiteread had started to pause there herself, to look at these spaces that others took for granted, to access routes that were never noticed. She had once again chosen to map the overlooked, and now – for the first time – she had used her own home as subject matter. Both *Untitled (Cast Iron Floor)* and *Untitled (Upstairs)* were cast from a disused synagogue in Bethnal Green in East London, which Whiteread and her partner Marcus Taylor bought in 1999 to convert into studios and a home. It was a building rich in history. Although located in an area that was once the heart of the Jewish community in London, the synagogue started out as a Baptist church. The synagogue, built in the early 1900s, was bombed in 1941, and the present brick-built synagogue reconstructed in 1957, but since the 1970s it had been used as a textiles warehouse. When Whiteread received the keys, musty rolls of spangly fabric and patterned silks filled the ground floor. She spent a month going through them and getting to know the building, reading its past through its contents and surface detail.

As Whiteread soaked in the history she had inherited – the central hall with its Star-of-David stained glass and its chandeliers, the two cramped apartments that once belonged to the Rabbi and caretaker, the narrow stairs down to the basement – she started to think about the logistics of taking casts from a building that she was soon going to renovate and change. The casts she took in the first year she was there, before the building was refurbished, were to become her record of the building's past. Like photographs or prints that she could archive, they would allow the history of the building to live on long after the flats had been removed, and her own apartment installed there. *Untitled (Cast Iron Floor)* was taken from the terracotta floor of the synagogue; *Untitled (Upstairs)* from the staircase leading up to the first-floor apartments. Whiteread also cast the other two concrete staircases that she found in the building (figs.72–3), as well as each apartment in its entirety.

Since the day in 1990 when Whiteread had entered her studio and, looking at *Ghost*, realised that she had become the wall, she had thought about how to reveal the wall space to the viewer. In *House*, the internal walls had remained to support the sculpture; in *Untitled (Room)* they had been removed, so that the resulting cast functioned like *Ghost*, positioning the viewer on the outside looking in. But with her casts of the two apartments in the synagogue, *Untitled (Apartment)* and *Untitled (Rooms)*, Whiteread finally found a way of revealing the slim spaces that divide bathrooms from kitchens, bedrooms from neighbours.

The two flats had been shoehorned into the synagogue, and were very basic, comprising a series of small rooms linked together by a narrow corridor. They reflected the economic hardship of post-war life in the East End, and had been unoccupied for decades when Whiteread first saw them. She cast them in plasticised plaster, a robust material with the toughness of fibreglass, and the blank release agent she used meant that the final sculptures showed little trace of the lives that had once been lived out within each space. With these casts, Whiteread wasn't focussing on her own life or the lives of those who once lived there, but on the physical space of the rooms in relation to each other and to us. Each is a sealed chamber, with no gaps between the panelled sections in which they were made, the ceilings cast to ensure no way in or out. Between them is a slender void, a wall of air that slices between the solid forms. Here, electric sockets and skirting can be glimpsed, the only block-

UNTITLED (BASEMENT) 2001 [72]
Mixed media
325 X 658 X 367 (128 X 259 X 144 ½)
Deutsche Guggenheim, Berlin

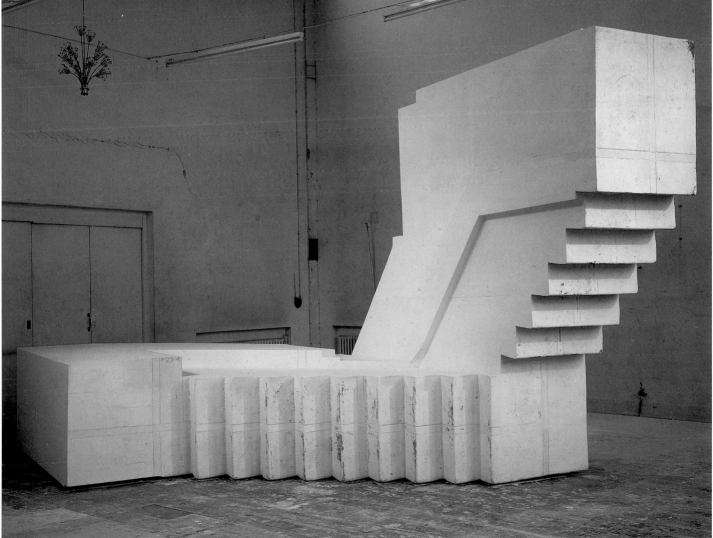

UNTITLED (STAIRS) 2001 [73]
Mixed media
375 X 550 X 200
(147 5/8 X 216 1/2 X 86 5/8)
Tate. Purchased with funds provided
by the National Art Collections Fund
and Tate Members 2003

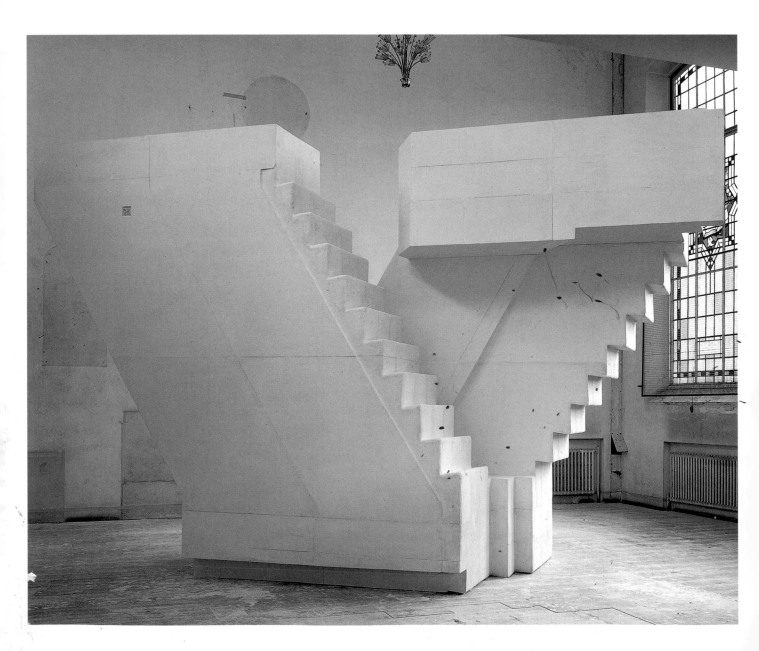

age between each room caused by the casting of the space between the doorframes. In this complex extension of all Whiteread's architectural work from the 1990s in which voids became solid, we are not the wall, but we can see the wall; here, solids also become tangible voids.

Untitled (Apartment), along with *Untitled (Basement)* (fig.72) – a cast of one of the three staircases in the building – was exhibited for the first time in Berlin. Whiteread had been offered a solo show at the Deutsche Guggenheim that was to tour subsequently to the Guggenheim in New York. Both galleries have very distinctive architecture, to which Whiteread initially felt that she should respond. But she realised that her own architecture would form a counterpoint to the grandeur of each site, and her casts from the synagogue formed the centrepiece of the show *Transient Spaces*.

While Whiteread's casts of the apartments laid to rest her desire to cast walls, her stair pieces such as *Untitled (Basement)* also allowed her to resolve her decade-long ambition to cast staircases. Ever since *House* she had wanted to cast stairs, filling sketchbooks with endless drawings of them. She blacked out postcards of cityscapes leaving only the steps visible, floating in the darkness; she photographed stairs worn down with use, and stairwells tacked onto the outside of buildings. But it was only when contemplating the stairs in the synagogue that she was able to resolve the problem of just how to cast such a perceptually tricky space.

The novelist A.M. Homes wrote of Whiteread that she could imagine her swallowing plaster if she were able to, in order to cast herself. Casting the staircases of her own building is perhaps the architectural equivalent. Stairs are the throat of a building, the place through which everyone and thing must pass to go from top to bottom. Stairs are not places in which you can be passive and stationary, but are sites of movement and dynamism, diagonals of space that cut through a building, linking floors and people. They do not exist in their own right, but are connectors, fragments of a building that offer transition rather than finality.

Whiteread cast the three staircases in panels. All three stairwells were topped and tailed with doors, allowing her to tie off each sculpture at both ends. For the first time, Whiteread used scale models to grasp how each solidified space would look, turning them over to alter their shape and function, working out how the final sculptures should be positioned. In doing so, she moved away from presenting casts of real space in a perceptually challenging yet ultimately honest way, to playing with the spatial casts to create new shapes and forms. In short, she moved from the real to the illusory.

To place architectural sculptures in a closed-in gallery space is to distance them from their place of origin. The whole apartments seen in the Guggenheim and – in 2002 – at Tate Britain, took on new life as both abstract spaces and places in which to live. But with the stair pieces, Whiteread distanced the work still further, swinging whole sections back to mirror others, splitting straight flights of steps in two, twisting access doors and landings.

Stairs have always been seen as illusory places, long before Escher drew endless puzzle-like constructions of them. They are the sites of visitations from God in Renaissance paintings and from ghosts in Victorian horror stories. Moving staircases in fiction – from Borges's *The Tower of Babel* to J.K. Rowling's *Harry Potter* – are designed to disorientate, and illustrate that nothing is as it seems. Staircases often feature in films as the creaking construct of horror, or

the scene of transition from life to death (the minimum dimensions of a domestic Victorian staircase were those required to allow three pairs of men to carry a coffin down it). Whiteread's staircases are highly complex sculptures that are impossible to navigate. They seem illogical, their reconfigurations taking reality to a place so far removed that the mind cannot bring it back.

Whiteread cast two further staircases in 2002, this time based on a fire escape at Haunch of Venison, a large commercial gallery in London. *Untitled (Domestic)* was shown in Whiteread's solo show, which inaugurated the space. Haunch of Venison is located in a house that was once used by Nelson to recuperate after battle, but Whiteread's decision to cast from the newest addition to the building – the fire escape – pointed to her waning interest in the specific history of buildings, and the waxing of her investigation into pure form. As with *Monument*, she was unable to cast on site, and had to reconstruct the stairwell in her studio as a full-scale model in order to cast from it, using rough-grained scaffold board to create the stairs, laying metal runners on the treads, and distressing the lino that covered them. It was a film set of a staircase, a flight of stairs that had never been used but looked well-worn. Although full-size, lying on its back its use was negated, the zigzag of the stairs running helplessly along the ground.

While Whiteread's work has increased in scale – from libraries to staircases and whole apartments – she has recently returned to studying her drawings, sketchbooks and photographs, looking for a way in which to scale her work back down. But in 2003 she was offered the chance to cast another room, this time at the BBC's Broadcasting House. It was Room 101, once thought to have been George Orwell's office when he worked there during World War II, and it was up for demolition. Room 101 entered the collective memory when Orwell's book *1984* was published in 1949. In the novel, Room 101 is the place of no return, a room so feared that even a whisper of it caused the comrades in Big Brother's doublethink regime to tremble and faint. As the interrogator O'Brien says to Winston, the central character in the book, who is eventually sent to Room 101: 'You asked me once what was in Room 101. I told you that you knew the answer already. Everyone knows it. The thing that is Room 101 is the worst thing in the world.'

By the time Whiteread entered the BBC's Room 101, located at the end of a lengthy corridor and bomb-damaged in the war, it had long since ceased to be an office and had become a haven for boilers and ventilation shafts. Whiteread stripped the room and, over a six-week period in April and May 2003, cast it in its entirety. In *1984*, Room 101 is buried deep underground; it turns out not to be a baroque torture chamber as Winston had feared but a prosaic and windowless room. Whiteread's cast (fig.74) has also been blinded; each window is filled in and divided by elaborate frames, a central cross scored into each one. It is a detailed cast, with recessed spaces where pipes once ran, a door unable to lead anywhere. It is the Room 101 of the mind, unnerving in its claustrophobic finality, a sealed tomb where all our worst fears are hiding. For in *1984*, it is not Room 101 in itself that is terrifying, it is the fears you bring to that room that destroy you. And, as with all of Whiteread's work, it is what you bring to her sculpture that ultimately gives it its intense, arresting power.

UNTITLED (ROOM 101) 2003 [74]
Mixed media
300 x 500 x 643
(118 x 197 x 253 3/8)
Private Collection

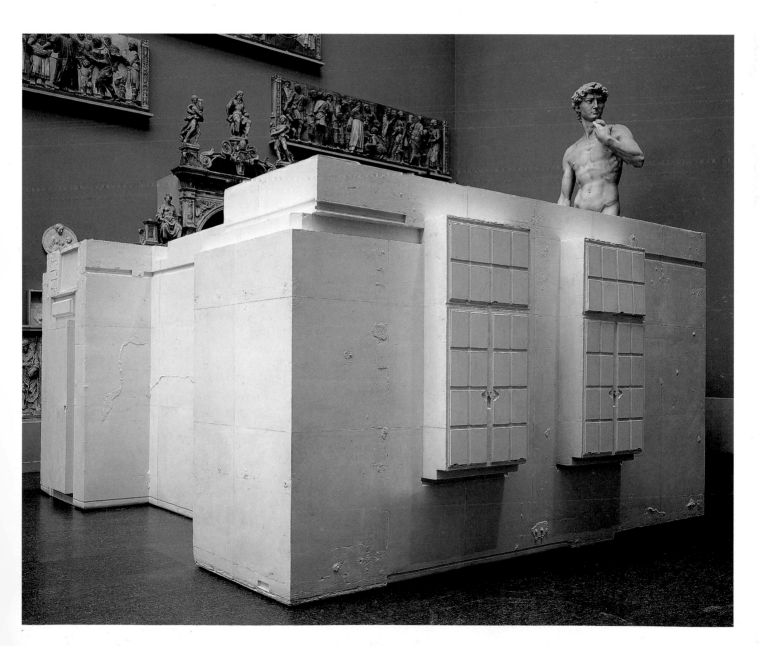

When Whiteread bought a disused synagogue in Bethnal Green in 1999, she felt drawn to map the building as a way of getting to know it.

When I started thinking about the building, I was combing every surface of it thinking about how we would change it to house the studio and meet my needs for both working and living. But I was also combing the surfaces for its history.

I began by thinking about the minutiae of the building, in terms of how one might change it and translate it into something more modern. I was really considering it in terms of living there, possibly for the rest of my life. I had never really thought about the details of a space in this manner before, except in terms of sculpture. So while I was busy being totally absorbed with the building and thinking about working with architects, I became drawn to the idea of creating a series of works related to the apartments, the staircases, and the floors.

Whiteread's work has often been linked to printmaking, to taking an impression of one surface and presenting it – in reverse – on another. The three stair pieces that she cast from the former synagogue before converting it, lifted prints of the treads and locked them into plasticised plaster for posterity.

I was delighted when I figured out how to make these works. Even though I've changed the building I still have a record of its past. Whether the pieces end up in Europe or America or in storage in my studio, it's satisfying to have made these impressions of a building that I'm probably going to be involved with for the rest of my life. I've never really done that before. Whenever I make a piece, the original objects are essentially destroyed.

Casting from the building wasn't a simple process. For one thing, Whiteread had to work out how to cast entire structural components without destroying them. She had done this on a smaller scale in *Ghost*, whose panelled form is in part replicated in all the synagogue works, since Whiteread had to extricate the casts from their mould through domestic-scaled doorways and corridors. But the stair pieces presented another complication – a conceptual as well as physical problem that Whiteread solved with 'crazy gymnastic backward thinking':

Physically and intellectually I couldn't work out how to do it. It took a long time to get the kind of knowledge of how to do something like that without actually destroying the staircase.

In fact, casting stairs had been on her mind throughout the 1990s, since the days of *House*.

When I made House, *the one thing that frustrated me was the staircase – we had to cut*

UNTITLED 2000 [75]
Ink on postcard
14.7 × 8.7 (5 3/4 × 3 3/8)
Private Collection

it in half, and cast around it, so the staircase was still in position when the work was finished.

Of the three pieces cast in situ – *Untitled (Basement), Untitled (Stairs)* and *Untitled (Upstairs)* – it was the latter that she felt should exist on its own as a singular piece of sculpture, without the accompanying cast suite of rooms (taken from the flats for the Rabbi and the caretaker) that were exhibited alongside the other two stair pieces. *Untitled (Upstairs)*, exhibited at the Serpentine Gallery in 2001, was the tallest piece. Its bottom door lay horizontally like the lid of a coffin, placed on top of a plaster tomb that was cast from the entranceway to the staircase. A short flight of five stairs ran up to a square landing, a longer flight ascending vertically towards a pulpit-like form that leant against the wall. In contrast to *Untitled (Stairs)*, which has a bulky symmetry and fans out like two splayed saw-blades, and *Untitled (Basement)*, which hugs the ground, *Untitled (Upstairs)* soars skywards.

Untitled (Basement) *is much more polite in its objectivity.* Untitled (Upstairs) *works differently, and I think it's partly due to the volume and the height, and being able to actually walk underneath it. But I also feel that it does something uncanny. It inverts your sense of place. It's almost like some of my very early pieces in the way it surprises people by turning the world inside out, which is what I understand people found so arresting. I think that* Untitled (Upstairs) *has done exactly that, due to a large degree to its scale. There's confusion about its relationship to the original stairs. You have this awkward lump that's sort of sticking up. I find it an incredibly uncomfortable, powerful and strange object, and I'm still trying to figure out why.*

Untitled (Upstairs) and the other staircases in the series mark a distinct change in Whiteread's work. For while she had constructed and manipulated space before – fabricating an interior for *Untitled (Room)*, constructing a plinth for *Monument*, blocking in each bathtub from which she cast – the stairs actually announce themselves as fictional places, puzzles with no solution. In part it was the construction of 1:10-scale models of each staircase that allowed her to work on this aspect. The whole staircase suddenly became malleable in her hands, its orientation changeable. But it was also due to the fact that, because you can see a flight of steps running along the surface of the plaster form, you read it as the original staircase. However, as with the majority of Whiteread's work, what you are actually seeing is the space from inside, in this case the interior of a stairwell. And by tipping up and turning on its head the orientation of the original staircase, Whiteread ensures that your mind cannot keep up with the perceptual tricks that the work plays out.

Whiteread is pleased with the disorientation caused by these works – something that she herself felt as *Untitled (Upstairs)* was reassembled for the first time in the central hall of the synagogue that forms her studio – since it suggests that viewers are experiencing the work physically. When the show transferred to Edinburgh, where the gallery ceiling was much lower than the Serpentine's central atrium, *Untitled (Upstairs)* was turned on its side. This transformed the sculpture, its lofty stairs now running along the ground more like a geometric puzzle than a staircase.

But I'm not trying to make an Escher drawing in which you have this annoying psychological game where you're trying to traipse your way around one of his puzzles. For me it's a physical experience.

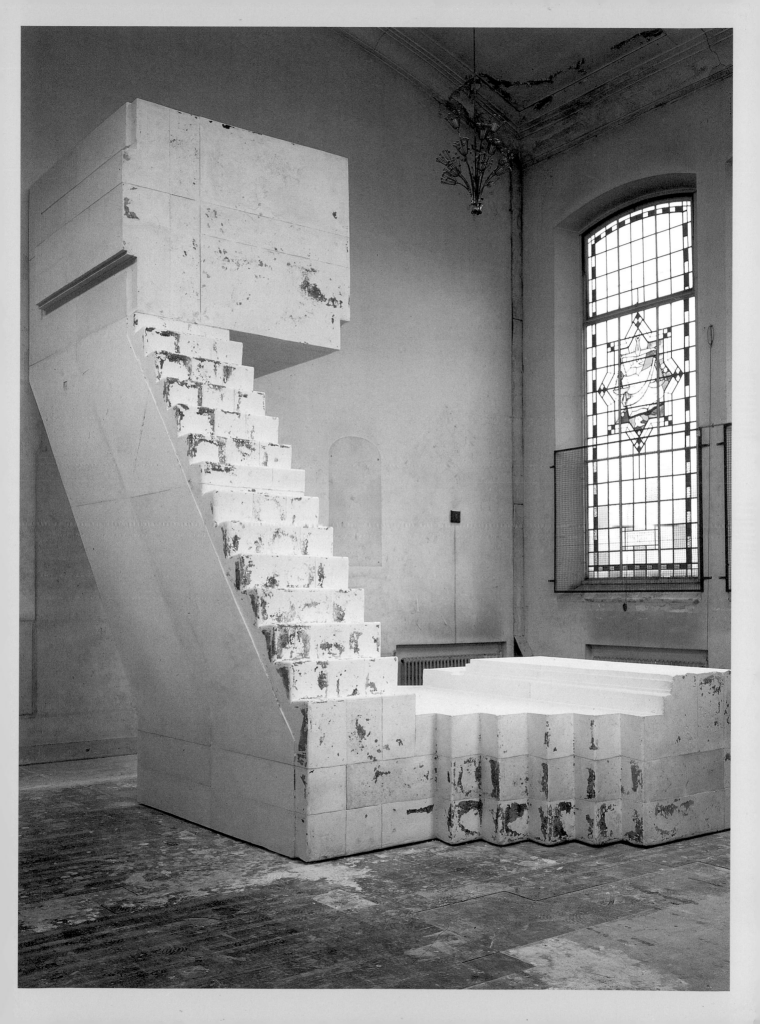

AN UNTIMELY DEATH: A CONTEXT FOR RACHEL WHITEREAD

In George Orwell's *1984*, Room 101 is a subterranean tomb, a place from which you can never escape. It is a place where only the worst things in the world come true, and top of the interrogator's list of 'worst things' is being buried alive.

The fear of being buried alive has rippled through fiction, film and psychoanalysis since the first human remains at Pompeii were discovered in the mid-eighteenth century. Fuelling the fear were subsequent excavations in Egypt and China, where thousands of skeletons were found in chambers surrounding the tombs of kings and rulers, seemingly buried alive as part of the funeral rites.

A popular reading of Whiteread's *House* was that it conveyed this idea of living interment. Whiteread herself talked of 'entombing' the rooms, and she and her team had to escape from the concrete-filled structure through a small hatch in the roof. This led columnists and cartoonists to speculate on what, or whom, might have been left inside when it was sealed up. Indeed, Whiteread's work in general – with its all-pervasive sense of untimely suffocation, of the claustrophobic smothering of social space and consequently life, of memories trapped within – taps into this collective fear of feeling, seeing, experiencing our own burial. As Edgar Allan Poe wrote in his short story 'Premature Burial': 'To be buried alive is, beyond question, the most terrific of … extremes which has ever fallen to the lot of mere mortality.'

THE DARK CLOUD

In AD 79 Pompeii was a thriving seaside resort for wealthy Romans, with a population of 20,000. But with the sudden eruption of Mount Vesuvius, and the great smothering clouds of ash and pumice that fell on Pompeii, all life in the town was obliterated. Pliny the Younger – who was seventeen at the time of the eruption and whose uncle, Pliny the Elder, lost his life trying to rescue trapped relatives from Vesuvius's reach – wrote of the cloud that mushroomed from the top of the volcano:

Its appearance can best be expressed as being like an umbrella pine, for it rose to a great height on a sort of trunk and then split off into branches, I imagine because it was thrust upwards by the first blast and then left unsupported as the pressure subsided … In places it looked white, elsewhere blotched and dirty, according to the amount of soil and ashes it carried with it.

The ash fell on Pompeii, covering temples, homes, brothels and shops, preserving sculptures and wall paintings, worktops and signposts, wheel ruts and pedestrian crossings, but, most dramatically, killing thousands of people.

Caught up in the fringes of the great cloud's descent, Pliny the Younger and his mother tried to run into the hills to escape it, but 'we were enveloped in night – not a moonless night or one dimmed by cloud, but the darkness of a sealed room without light … from time to time we had to get up and shake [the ashes] off for fear of being actually buried and crushed under their weight.' This account of his survival must echo the experiences of those who were not so lucky, the thousands of inhabitants who were literally buried alive in Pompeii.

The initial excavations were carried out in 1748, uncovering buildings under several metres of pumice. Work began in earnest a decade later, and soon young men on the Grand Tour, who had previously been limited to the study of Greek and Roman artefacts, flocked there to marvel at the realities of the past uncannily brought back to life. But it would be

Cartoon by Kipper Williams, published in *Time Out*, 3–10 November 2003 [77]

another century before Giuseppe Fiorelli, director of excavations, discovered a way to preserve the 'bodies' they found there. The Romans had long since decomposed in their airless tomb, and only human-shaped holes found in the solid volcanic layer pointed to their positions. Into these Fiorelli poured plaster of Paris, to create solid casts of these ghostly outlines, the original moulds then chipped away to reveal the bodies. As with Whiteread's sculptures, the history-rich original had to be destroyed to reveal a cast of the space within.

Eighteenth-century art historians such as Johann Joachim Winckelmann had obtained their knowledge of Roman life chiefly through statuary depicting officials and dignitaries or mythological gods and goddesses. These sculptures were often fragmented and usually bleached white, the bright colours of the original pigments long since eroded away. They led to an idealised reverence for the elegance and classicism of a world built, it was supposed, out of order and harmony. But while the casts made of the former inhabitants of Pompeii were also colourless, they were everything the sculptures were not. They captured the folds of real Roman tunics as they bulged at the waist; they traced the lines of sandals, the curls of hair and the grimaces on individual faces as they gasped their last breaths. All possible shapes and sizes, lying lifeless where they had fallen, these bodies were the exact reverse of Pygmalion's perfect marble sculpture that sprang to miraculous life.

The architectural theorist Anthony Vidler devotes a whole chapter of his book *The Architectural Uncanny* 1994 to Pompeii's live burials. He cites the nineteenth-century writers François René de Chateaubriand and Théophile Gautier, who both fantasised about the imprint of a girl's breast found in the earth at the foot of a colonnade, bringing the girl back to life in their writings. As Chateaubriand said, 'Death, like a sculptor, has moulded his victim.' There was, and still is, a morbid fascination with seeing these casts made from real people. The moulds from which the human casts were made were once-removed from life, and allowed poets, writers and artists to romanticise about the people who had once filled them. But still there remained the frisson of fear, with Vesuvius ominously silent in the not-so-distant background.

Freud, in his 1919 essay 'The Uncanny', said that 'to some people the idea of being buried alive by mistake is the most uncanny thing of all', and described the concept as a 'terrifying fantasy'. His coupling of these two words makes apparent the seduction of the Pompeii casts, the idea that untimely death can be erotic, as it was for Chateaubriand and Gautier, and has continued to be for subsequent generations of writers. The protagonists in the novel *Crash* 1973, for example, written by J.G. Ballard (one of Whiteread's favourite authors), got their kicks from haunting car wrecks, looking for dead victims:

The whiteness of his arms and chest and the scars that marked his skin ... gave his body an unhealthy and metallic sheen, like the worn vinyl of the car interior. These apparently meaningless notches on his skin, like the gouges of a chisel, marked the sharp embrace of a collapsing passenger compartment, a cuneiform of the flesh formed by shattering instrument dials, fractured gear levers and parking-light switches. Together they described an exact language of pain and sensation, eroticism and desire.

A similar duality is present in much of Whiteread's work: an initial sense of seductive familiarity with the everyday forms; a disturbing feeling of exclusion and

Naples, Italy, 1961. Archaeological workers extract the mummified bodies of two adults and three children from their earthen mould [78]

Karl Pavlovic Briullov
THE LAST DAY OF POMPEII 1833 [79]
The State Russian Museum

UNTITLED (TWENTY-FOUR
SWITCHES) 1998 [80]
Cast aluminium
26.3 x 20.3 x 6 (10 3/8 x 8 x 2 3/8)
Tate. Purchased 2003

loss when the inside-out conceptualism of each sculpture reveals itself and the destruction of the original object is understood.

Freud was himself haunted by dreams of being buried alive, and deconstructed his own subconscious fears in his opus *The Interpretation of Dreams* of 1899. But while the human voids at Pompeii were cast by early archaeologists – air made solid as in Whiteread's series of *Torsos* cast from hot-water bottles – the chief archaeological sites were architectural. In much of Whiteread's work, whole rooms, buildings or apartments have been solidified, and Pompeii is indexical in a similar way to her working method: the two forms – positive and negative, mould and cast imprint – form a snug whole before they are separated.

While all towns entomb themselves over time – the Roman spa at Bath is six metres below street-level today – Pompeii sank without trace in just one day. As it was slowly being uncovered, Wilhelm Jensen wrote in *Gradiva: A Pompeiian Fancy,* in 1903: 'What had formerly been the city of Pompeii assumed an entirely changed appearance, but not a living one; it now appeared rather to become completely petrified in dead immobility. Yet out of it stirred a feeling that death was beginning to talk.' Traces of everyday life left on the walls or the ground hinted at the everyday nature of events prior to the eruption – a wall half plastered, the remains of food in the bottom of jars on a serving counter, a loaf of bread scored into eight pieces in an oven. Similar traces have been left on Whiteread's rooms, such as the soot and paint in *Cell* (fig.81), *Ghost* and *House*. With Whiteread's work, the past domestic life of the space has also been excavated, but it is encased like a fossil in limestone, its once-dynamic spaces now smothered. Even her recent series of staircases denies access to the space

that would be needed to walk up and down the treads, casting a solid from a void just as the archaeologists created Romans from their imprints. Whiteread's city is perpetually being buried, spaces becoming filled up like the town of Argia in Italo Calvino's fictional account of Marco Polo's travels in *Invisible Cities* (1972): 'What makes Argia different from other cities is that it has earth instead of air. The streets are completely filled with dirt, clay packs the rooms to the ceiling, on every stair another stairway is set in negative.'

Eight years after the discovery of Pompeii, reports reached England of a contemporary tragedy, again of death by suffocation, in Calcutta. According to a sole report published by a survivor in 1758, 146 people had been imprisoned in a small, windowless, airless dungeon at Fort William. Overnight, 123 of them died. The story of the Black Hole of Calcutta – while now thought to be an exaggerated account – so captured the imagination that it remains in the English vernacular today. Edgar Allan Poe's most famous short story, *The Pit and the Pendulum*, a Gothic tale published in 1842, summed up the popular fear of claustrophobic incarceration. The prison in which the story is set is windowless, the air inky black, the walls slowly moving in and compressing the space left within the room. Looking at *Closet*, or *Untitled (Black Bed)*, memories of the absolute fear of solid blackness often experienced as a child crowd in like the walls of Poe's dungeon.

TOMB RAIDERS

Egyptian excavations had begun half a century before Poe's story was written. While Egyptology initially involved measuring and documenting objects and artefacts on the surface – including the Rosetta Stone

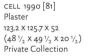

CELL 1990 [81]
Plaster
123.2 X 125.7 X 52
(48 ½ X 49 ½ X 20 ½)
Private Collection

during Napoleon's first Egyptian expedition of 1799 – soon temples were being dug from the sand, and the tombs of the Valley of the Kings were being explored. The Romantic poet Percy Bysshe Shelley, who lived much of his life in Italy (land of the Grand Tourists) and died aged thirty in 1822, wrote of the fascination of the British with the Egyptian past in 'Ozymandias':

> I met a traveller from an antique land
> Who said: Two vast and trunkless legs of stone
> Stand in the desert . . . Near them, on the sand,
> Half sunk, a shattered visage lies, whose frown,
> And wrinkled lip, and sneer of cold command,
> Tell that its sculptor well those passions read
> Which yet survive, stamped on these lifeless
> things . . .

These hard-stone figures in porphyry and marble, ancient echoes of a lost empire, were found all over Egypt, especially within or surrounding the Pyramids. For it was in the Pyramids that the Pharaohs lay, mummified for the afterlife, their vital organs carefully stored in Canopic jars, food and drink piled high in outer chambers, with hundreds of dead servants and soldiers lying nearby to serve and service them on the 'other side'. On finding these endless bodies in the chambers circling the royal tombs, archaeologists surmised that they must have walked into each Pyramid and been bricked in, buried alive to accompany the Pharaoh on his journey to eternal life. Once dead, the ancient Egyptians believed, the Pharaoh would come out of his tomb via a number of false doors painted on the inside of his sarcophagus and carved on the inside of the inner chamber. Whiteread cast her own *False Door* in 1990 (fig.82), the pale flaky plaster reminiscent of the chipped stone of the False Door of Kaihap, from *c*.2450 BC (fig.83), now in the British Museum (in whose Egyptian rooms Whiteread has spent many hours). *False Door* is panelled on only one side, and – like a false door in a tomb – its 'access point' is not visible to those approaching from outside. Positioned less than a foot from the wall and presenting a blank face of six sheer blocks to the viewer, not even the hole where the handle should connect through the door punctures the facade. This door is not to be used physically, but occupies the realm of the imagined.

For Egyptians, life on earth was only one step in an eternal cycle, hence the immense rituals practised for the highest level of society: mummification alone took seventy days. People flocked to see these exhumed mummies – most notably Tutankhamun's in 1922, discovered by Howard Carter. When Tutankhamun's mummy and artefacts were first exhibited at the British Museum in 1972, people queued for hours for a glimpse of the bandaged eighteen-year-old king, whose body was remarkably still preserved after three-and-a-half thousand years.

Stories of mass sacrifice following the death of a leader also surfaced in China, as ancient burial sites were excavated. The remains of servants, grooms and warriors were found alongside horses and carriages in sunken buildings surrounding the main tomb. While it transpired that the Egyptians had taken poison and the Chinese were killed before being buried, the idea that they had been entombed alive lived on in people's subconscious.

BEYOND THE GRAVE

In Britain, people may – on the whole – only have been buried after they were dead, but corpses rarely had a peaceful existence. By the nineteenth century, graveyards had become so overcrowded that bodies were often moved and stacked one on top of another.

FALSE DOOR 1990 [82]
Plaster
214.5 X 40.5 X 101.5
(84 ½ X 16 X 40)
British Council Collection

The False Door of Kaihap c.2450 BC
in the Egyptian Galleries at the
British Museum [83]

To avoid this, the wealthy paid a premium to be buried under the flagstones of churches. In 1843 a parliamentary committee officially recommended the installation of cemeteries. Seen by the church as godless – they were commercial ventures, often sited far from any parish church – cemeteries nevertheless revolutionised death in Victorian England.

Highgate cemetery (fig.85) opened in 1839, and soon became the *de rigeur* place to bury your loved ones. The western sector was designed with sweeping avenues and tall trees. Rows of Gothic Revival mausolea were placed on the hillside, and catacombs were created below ground level, encircling the Cedar of Lebanon. Cremation was not made legal until 1902, and consequently bodies were buried in ornate, windowless tombs. In the twentieth century burial space was becoming scarce, and interest in the Cemetery was declining, and in 1975 the west cemetery closed. Only the dedicated work of hundreds of volunteers brought back some semblance of the Gothic grandeur it had once possessed, and allowed it to reopen – for visitors if not corpses. Whiteread was one of those volunteers, a teenage helper hacking away at the fingers of thorny brambles that smothered the graves, witnessing the vandalism that had desecrated so many of the tombs, their stone doors cracked and caved in, dark glooms of space welling up behind. While no-one was knowingly buried alive at Highgate, several bodies – including Rossetti's wife Elizabeth Siddall and Mary Shelley's parents – were disinterred, and the stories that surrounded the graveyard must have intrigued the young Whiteread, who was terrified of, yet intrigued by, these gaping houses of the dead. This overpowering architecture of death has had repercussions that have affected much of Whiteread's work, including the flaky tombstone walls of *Ghost*, the book-studded mausoleum of *Holocaust Memorial* and many of her casts of tables, monumental despite their domestic scale.

Tombs, graveyards and cemeteries have been the sites of cinematic resurrections since film began, most notably in the Boris Karloff horror *The Mummy* of 1932 and the Hammer classic of the same name made in 1959. They are the locations where life and death most easily commingle in the mind, changing places in your imagination. Other films have tackled the theme of live burial, from the 1917 silent movie *Buried Alive* to the 1988 film *The Vanishing*, directed by George Sluizer. And, as with all of the sites mentioned – the smothered rooms of Pompeii, the airless Black Hole of Calcutta, Egyptian and Chinese tombs with their solid windowless architecture – a solid darkness, as made palpable by Whiteread in *Closet* or *Untitled (Black Bed)*, is linked with the claustrophobic fear of suffocation, of dying an unnatural death. In Poe's 'The Cask of Amontillado', 1846, he translates this fear into a long walk down into a dank, nitrous dungeon, the would-be killer leading his drunk associate further under the city until they reach the final tomb-like chamber, which is full of human remains. In it, a recess has been left 'between two of the colossal supports of the roof of the catacombs, and was backed by one of their circumscribing walls of solid granite'. The killer thrusts the drunkard into the recess, and chains him to the wall. Then, slowly, he bricks him in.

It was now midnight, and my task was drawing to a close. I had completed the eighth, the ninth, and the tenth tier. I had finished a portion of the last and the eleventh; there remained but a single stone to be fitted and plastered in. But now there came from out of the niche a low laugh that erected the hairs upon my head ... I forced the last stone into its position; I plastered

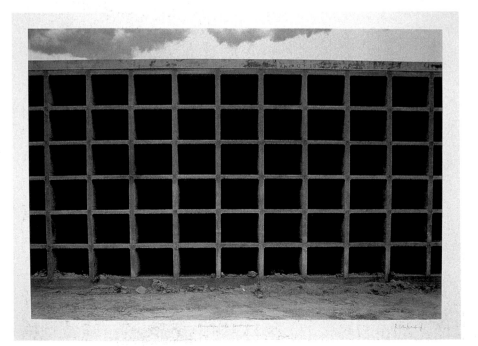

MAUSOLEUM UNDER CONSTRUCTION
1992 [84]
Screenprint and mezzotint on paper
56 x 79 (22 x 31)
Tate. Acquired by purchase and gift
from Charles Booth-Clibborn in
memory of Joshua Compston 1997

it up. Against the new masonry I re-erected the old rampart of bones. For the half of a century no mortal had disturbed them. In pace requiescat!

While much of Whiteread's work initially talks of memory and memorialising, it is the physicality of its production, the dense materials – plaster, concrete, resin – used to smother forms, and the emphatic deadening of lived-in space that sends dark shudders down the spine and quickens the onlooker's breath. Life has been snuffed out with all the finality of Vesuvius's downpour.

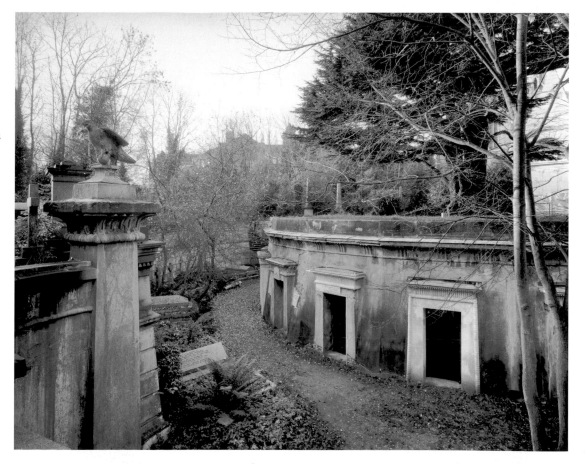

Highgate Cemetery [85]
View of the inside of the Catacombs from above the entrance view from the North East. Photographer unknown

Biography

1963 Born in London
1983–5 Brighton Polytechnic (Painting)
1985–7 Slade School of Fine Art (Sculpture)
1992–3 DAAD Scholarship, Berlin
1993 Awarded the Turner Prize
1997 Awarded the Venice Biennale Best
 Young Artist award
Lives and works in London

Solo Exhibitions

1988 Carlisle Gallery, London
1990 *Ghost*, Chisenhale Gallery, London
1991 Arnolfini Gallery, Bristol
 Rachel Whiteread: Sculptures, Karsten
 Schubert, London
1992 *Rachel Whiteread: Recent Sculpture*,
 Luhring Augustine Gallery, New York
 Rachel Whiteread: Sculptures, Sala
 Montcada de la Fundació 'La Caixa',
 Barcelona
 Rachel Whiteread: Sculptures 1990–1992,
 Stedelijk Van Abbemuseum, Eindhoven
1993 Galerie Claire Burrus, Paris
 Rachel Whiteread: Sculptures, Museum
 of Contemporary Art, Chicago
 House, commissioned by Artangel and
 Beck's, London
 Rachel Whiteread: Zeichnungen, DAAD
 Galerie, Berlin
1994 *Rachel Whiteread: Works on paper*,
 Galerie Aurel Scheibler, Cologne

*Rachel Whiteread:
Skulpturen/Sculptures*, Kunsthalle,
Basel, ICA Philadelphia, ICA Boston
Rachel Whiteread: Drawings, Luhring
Augustine Gallery, New York
1995 *Rachel Whiteread: Sculptures*, British
School at Rome
Rachel Whiteread: Untitled (Floor),
Karsten Schubert, London
1996 *Rachel Whiteread : Demolished*, Karsten
Schubert, London, in collaboration with
Charles Booth-Clibborn
Rachel Whiteread: Sculptures, Luhring
Augustine Gallery, New York
*Rachel Whiteread:
Skulpturen/Sculptures 1988–1996*, Max
Gandolph Bibliothek, Salzburg; Herbert
von Karajan Centrum, Vienna
Rachel Whiteread: Shedding Life, Tate
Gallery, Liverpool
1997 *Rachel Whiteread*, Palacio Velázquez,
Centro de Arte Reina Sofía, Madrid
British Pavilion, Venice Biennale, Venice
Water Tower Project, Public Art Fund,
New York
Rachel Whiteread, Anthony d'Offay
Gallery, London
1999 *Rachel Whiteread*, Luhring Augustine
Gallery, New York
2000 *Holocaust Memorial*, Judenplatz, Vienna
2001 *Monument*, Fourth Plinth, Trafalgar
Square, London
Rachel Whiteread, Serpentine Gallery,
London, Scottish National Gallery of
Modern Art, Edinburgh
Rachel Whiteread: Transient Spaces,
Deutsche Guggenheim, Berlin,
Guggenheim, Bilbao, Solomon R
Guggenheim Museum, New York
2002 *Rachel Whiteread*, Haunch of Venison,
London
2003 *Rachel Whiteread*, Luhring Augustine,
New York, NY
Rachel Whiteread, Koyanagi Gallery,
Tokyo
Room 101, Victoria & Albert Museum,
London

Selected Group Exhibitions

1987 *Whitworths Young Contemporaries*,
Whitworth Art Gallery, Manchester
1988 *Riverside Open*, Riverside Studios,
London
Slaughterhouse Gallery, London
1989 *Whitechapel Open*, Whitechapel Art
Gallery, London
Einleuchten, Deichtorhallen, Hamburg
1990 *British Art Show*, McLellan Galleries,
Glasgow, Leeds City Art Gallery, Leeds,

Hayward Gallery, London
1991 *Metropolis*, Martin Gropius Bau, Berlin
Broken English, Serpentine Gallery,
London
*Katharina Fritsch, Robert Gober,
Reinhard Mucha, Charles Ray and
Rachel Whiteread*, Luhring Augustine
Gallery, New York
*Turner Prize Exhibition: Ian Davenport,
Anish Kapoor, Fiona Rae, Rachel
Whiteread*, Tate Gallery, London
*Confrontaciones 91: Arte Último
Británico y Espanol*, Palacio Velázquez,
Centro de Arte Reina Sofía, Madrid
1992 *Doubletake: Collective Memory And
Current Art*, Hayward Gallery, London
Young British Artists I, Saatchi Gallery,
London
Skulptur Konzept, Galerie Ludwig
Krefeld
Documenta IX, Kassel
London Portfolio, Karsten Schubert,
London
The Boundary Rider, Sydney Biennale,
Sydney
1993 *In Site: New British Sculpture*, National
Museum of Contemporary Art, Oslo
*Then and Now: Twenty-Three Years at
the Serpentine Gallery*, Serpentine
Gallery, London
Made Strange: New British Sculpture,
Museum Ludwig, Budapest
*The Sublime Void: An Exhibition on th[e]
Memory of the Imagination*, Koninklijk[e]
Museum voor Scone Kunsten, Antwer[p]
Whiteness and Wounds, The Power
Plant, Toronto
*Turner Prize Exhibition: Hannah Collin[s]
Vong Phaophanit, Sean Scully, Rachel
Whiteread*, Tate Gallery, London
1994 *Visione Britannica: Notions of Space*,
Valentina Moncada Gallery, Rome
*Sense and Sensibility: Women Artists
and Minimalism in the Nineties*, The
Museum of Modern Art, New York
Artists' Impressions, Kettle's Yard,
Cambridge
1995 *Ars 95*, Museum of Contemporary Art
and Finnish National Gallery, Helsinki
*Five Rooms: Richard Hamilton, Reinh[ard]
Mucha, Bruce Nauman, Bill Viola and
Rachel Whiteread*, Anthony d'Offay
Gallery, London
Here & Now, Serpentine Gallery,
London
Brilliant: New Art From London, Walk[er]
Art Centre, Minneapolis, Contempor[ary]
Arts Museum, Houston
*Prints and Drawings: Recent Aquisiti[ons]
1991–1995*, British Museum, London

Carnegie International 1995, Carnegie Museum of Art, Pittsburgh
International Istanbul Biennale, Istanbul Foundation for Culture & Arts, Istanbul
Drawing the Line, Whitechapel Art Gallery, London, Southampton City Art Gallery, Southampton

1996 *Un siècle de sculpture anglaise*, Galerie Nationale du Jeu de Paume, Paris
Mahnmal und Gedenkstätte fur die Jüdischen Opfer des Naziregimes in Österreich 1938–1945, Kunsthalle Wien, Vienna
Distemper: Dissonant Themes in the Art of the 1990s, Hirschhorn Museum and Sculpture Garden, Washington

1997 *Skulpture Projekte*, Munster, Germany
Sensation: Young British Artists from The Saatchi Collection, Royal Academy of Arts, London, Hamburger Bahnhof, Berlin, Brooklyn Museum of Art, New York
Art from the UK, Sammlung Goetz, Munich

1998 *Wounds*, Moderna Museet, Stockholm
Displacements: Miroslaw Balka, Doris Salcedo, Rachel Whiteread, Art Gallery of Ontario, Toronto
Toward Sculpture, Fundaçao Calouste Gulbenkian, Lisbon
Real/Life: New British Art, Tochigi Prefectural Museum of Fine Arts, Fukuoka Art Museum, Hiroshima City Museum of Contemporary Art, Tokyo Museum of Contemporary Art, Ashiya City Museum of Art
Claustrophobia, Ikon, Birminham; Middlesborough Art Gallery, Mappin Art Gallery, Sheffield, Dundee Contemporary Art Centre, Cartwright Hall, Bradford
Thinking Aloud, Kettle's Yard, Cambridge, Cornerhouse, Manchester, Camden Arts Centre, London

1999 *House of Sculpture*, Modern Art Museum of Fort Worth, Texas, Museo de Arte Contemporáneo de Monterrey, Mexico
Threshold: Invoking the Domestic in Contemporary Art, John Michael Kohler Arts Center, Sheboyga
Ten for the Century: a view of sculpture in Britain, De La Warr Pavilion, Bexhill on Sea

2000 *Le Temps, Vite*, Centre national d'art culture Georges Pompidou, Paris
Ant Noises, Saatchi Gallery, London
Between Cinema and a Hard Place, Tate Modern, London
Open Ends: 11 Exhibitions of

Contemporary Art from 1960 to Now, MoMA, New York
HouseShow: The House in Art, Deichtorhallen, Hamburg

2001 *Century City*, Tate Modern, London
Public Offerings, LA MoCA, Los Angeles
Collaborations with Parkett: 1984 to Now, MoMA, New York

2002 *The Photogenic: Photography Through Its Metaphors in Contemporary Art*, ICA, Philadelphia
Thinking Big: Concepts for 21st century British sculpture, Peggy Guggenheim Collection, Venice, Italy
Blast to Freeze: British Art in the 20th Century, Kunstmuseum Wolfsburg, Les Abattoirs, Toulouse, France
Jeff Wall and Rachel Whiteread, Kukje Gallery, Seoul

2003 *Days Like These*, Tate Britain, London

Selected catalogues, books and articles

1990 *Ghost*, exh. pamphlet, Chisenhale Gallery, London. Text by Liam Gillick
Liz Brooks, 'Rachel Whiteread: Chisenhale', *Artscribe*, Nov.–Dec.
Andrew Graham-Dixon, 'An Artist's Impression', *Independent*, 3 July
Andrew Renton, 'Rachel Whiteread: Chisenhale', *Flash Art*, Oct.

1991 *Broken English*, exh. cat., Serpentine Gallery, London. Essay by Andrew Graham-Dixon
Liam Gillick and Andrew Renton, *Technique Anglaise: Current Trends in British Art*, London and New York
Michael Archer, 'Ghost Meat', *Artscribe*, summer issue
Anthony Bond (ed.), *The Boundary Rider: 9th Biennale of Sydney*, exh. cat., Sydney
Lynne Cooke and Greg Hilty (eds.), *Doubletake: Collective Memory and Current Art*, exh. cat., South Bank Centre, London
Liam Gillick, 'Doubletake', *Art Monthly*, March
Robert Taplin, 'Rachel Whiteread at Luhring Augustine', *Art in America*, Sept.
Sarah Kent, 'Rachel Whiteread', *Modern Painters*, summer issue

1993 Karin Hellandsjo (ed.), *In Site: New British Sculpture*, exh. cat., Museum of Contemporary Art, Oslo
Beryl Wright (ed.), *Rachel Whiteread*, exh. cat., Museum of Contemporary Art, Chicago

James Yood, 'Rachel Whiteread: Museum of Contemporary Art', *Artforum*, Jan.
Rachel Whiteread: Gouachen, exh. cat., DAAD Galerie, Berlin. Essay by Friedrich Meschede
Rachel Whiteread Plaster Sculptures, exh. cat., Karsten Schubert and Luhring Augustine Gallery, New York. Essay by David Batchelor
Rachel Whiteread: Sculptures, exh. cat., Stedelijk Van Abbemuseum, Eindhoven. Interview by Iwona Blazwick
Ijsbrand van Veelen, 'Rachel Whiteread: Van Abbemuseum', *Flash Art*, May–June
Andrew Graham-Dixon, 'This is the house that Rachel built', *Independent*, 2 Nov.
John McEwan, 'The house that Rachel unbuilt', *Sunday Telegraph*, 24 Oct.
James Hall, 'I can't go on but…', *Guardian*, 4 Nov.

1994 *House*, Artangel Trust, London
Peter Fleissig (ed.), *Invisible Museum: Seeing the Unseen*, exh. cat., Thirty Shepherdess Walk, London
Parkett No.42, 'Lawrence Weiner and Rachel Whiteread', Zurich. Texts by Adam Brooks, Trevor Fairbrother, Richard Francis, Daniela Salvioni, Rudolphe Schmitz, Dieter Schwartz, Neville Wakefield and Simon Watney
Rachel Whiteread: Sculptures/Skulpturen, exh. cat., Kunsthalle Basel; ICA, Boston; ICA Philadelphia. Essay by Christophe Grunenberg
Jean-Pierre Criqui, 'Rachel Whiteread: Kunsthalle, Basel', *Artforum*, Nov.
Judith E. Stein, 'Rachel Whiteread: Insitute of Contemporary Art', *Artnews*, summer issue
Sarah Kent, *Shark Infested Waters*, London
Lynn Zelevansky (ed.), *Sense and Sensibility: Women Artists and Minimalism in the Nineties*, exh. cat., Museum of Modern Art, New York
Adrian Searle, 'Rachel doesn't live here any more', *Frieze*, Jan./Feb.

1995 *Excavating the House*, VHS video and audiotape, Institute of Contemporary Arts, London. Contributions from Jon Bird, Mark Cousins, James Lingwood and Doreen Massey
James Lingwood (ed.), *House*, London. Essays by Jon Bird, Doreen Massey, Iain Sinclair, Richard Shone, Neil Thomas, Anthony Vidler and Simon Watney
Rachel Whiteread: House, VHS video,

Artangel and Hackneyed Productions, London
Rachel Whiteread: Sculptures, exh. cat., British School at Rome. Essay by Pier Luigi Tazzi
Lynne Cooke, 'Rachel Whiteread', *Burlington Magazine*, April

1996
Lynn Barber, 'In a private world of interiors', *Observer*, 1 Sept.
Rosalind Krauss, 'Making space matter', *tate: the art magazine*, winter issue
Mark Cousins, 'Inside outcast', *tate: the art magazine*, winter issue
Adrian Searle, 'World of interiors', *Guardian*, 17 Sept.
Rachel Whiteread: Shedding Life, exh. cat., Tate Gallery Liverpool. Essays by Fiona Bradley, Stuart Morgan, Bartolomeu Marí, Rosalind Krauss and Michael Tarantino
Tim Hilton, 'Of Innocence and Experience', *Independent*, 22 Sept.
David Batchelor, 'Rachel Whiteread', *Burlington Magazine*, Dec.
William Feaver, 'Rachel Whiteread', *Artnews*, Dec.

1997
Rachel Whiteread, exh. cat., Venice Biennale, British Council, London. Interview by Andrea Rose
Patricia Bickers, 'Last Exit to Venice', *Art Monthly*, July–Aug.
Simon Hattenstone, 'From House to Holocaust', *Guardian*, 31 May
Tom Lubbock, 'The shape of things gone', Modern Painters, autumn issue
Claire Doherty (ed.), *Claustrophobia*, exh. cat., Ikon, Birmingham
Towards Sculpture, exh. cat., Centro de Arte Moderna José de Azeredo Perdigao, Lisbon. Text by Rui Sanches
Displacements, exh. cat., Art Gallery of Ontario. Essays by Jessica Bradley and Andreas Huyssen
Real/Life: New British Art, exh. cat., Tochigi Prefectural Museum of Fine Arts, Fukuoka Art Museum, Hiroshima City Museum of Contemporary Art, Museum of Contemporary Art Tokyo, Ashiya City Museum of Art. Essays by James Roberts and Andrea Rose
Thinking Aloud, exh. cat., Kettle's Yard, Cambridge, Cornerhourse, Manchester, Camden Arts Centre, London. Essay by Nick Groom
Rachel Whiteread, exh. cat., Anthony d'Offay Gallery, London. Text by A.M. Homes
Marcus Field, 'Feeding Frenzy', *Blueprint*, Dec.
'Carving Space: Interview with David

Sylvester', *tate: the art magazine*, spring
Robert Storr, 'Remains of the Day', *Art in America*, April
Jane Burton, 'Concrete Poetry', *Artnews*, May
Louise Neri (ed.), *Looking Up: Rachel Whiteread's Water Tower*, Public Art Fund, New York. Texts by Neville Wakefield, Tom Eccles, Luc Sante and Molly Nesbit
Andrea Schlieker, *Judenplatz: Place of Remembrance*, Museum Judenplatz, Vienna
Adrian Searle, 'Austere, Silent and nameless', *Guardian*, 26 Oct.
Euan Ferguson, 'Deadly Art of Remembrance', *Observer*, 29 Oct.
James E. Young, *At memory's edge: after-images of the Holocaust in contemporary art and architecture*, New Haven and London
Sincerely Yours: Rachel Whiteread, exh. cat., Astrup Fearnley Museum of Modern Art, Oslo, Norway. Essay by Øystein Ustvedt
Anda Rottenberg (ed.), *Amnesia*, exh. cat., Neues Museum Weserburg, Bremen
Rachel Whiteread, exh. cat., Serpentine Gallery, London and Scottish National Gallery, Edinburgh. Essays by Lisa Corrin, Patrick Elliott and Andrea Schlieker
James Beechey, 'Materials Girl', *Financial Times Weekend*, 16 June
Rose Aidin, 'A sculptor who casts a long shadow', *Sunday Telegraph*, 17 June
Charlotte Mullins, 'Exposed: the space beneath the stairs', *Independent on Sunday*, 17 June
Richard Cork, 'Transfixed by baleful stairs', *The Times*, 27 June
Rachel Whiteread: Transient Spaces, exh. cat., Deutsche Guggenheim, Berlin. Essays by Lisa Denison, Craig Houser, Beatriz Colomina, A.M. Homes and Molly Nesbit
Paul Schimmel (ed.), *Public Offerings*, exh. cat., Museum of Contemporary Art, Los Angeles
Double Vision, exh. cat., Galerie fur Zeitgenosaische Kunst, Leipzig. Essay by Andrea Schlieker
Uta Grosenick (ed.), *Women Artists in the 20th and 21st Century*, Cologne
Lynn Barber, 'Someday my plinth will come', *Observer Magazine*, 27 May

2002
Rachel Whiteread, exh. cat., Kukje Gallery, Seoul. Essay by Patrick Elliott
Henry Meyric Hughes and Gijs van Tuyl (eds.), *Blast to Freeze: British Art in the 20th Century*, exh. cat., Kunstmuseum

Wolfsburg
Rachel Whiteread, exh. cat., Haunch of Venison, London. Essays by Christiane Schneider and Susanna Greeves

2003
Lesley Garner, 'Home truths', *Independent Magazine*, 15 Feb.
Days Like These, exh. cat., Tate Britain, London. Text by Clarrie Wallis

Copyright credits

Photographic credits

Index